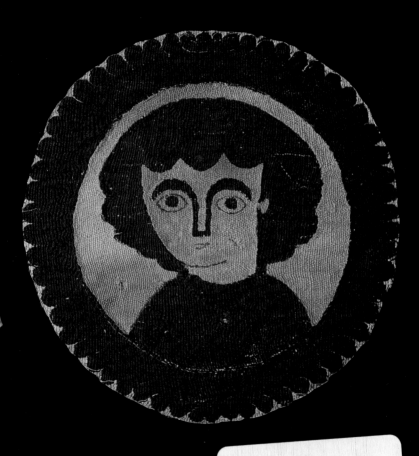

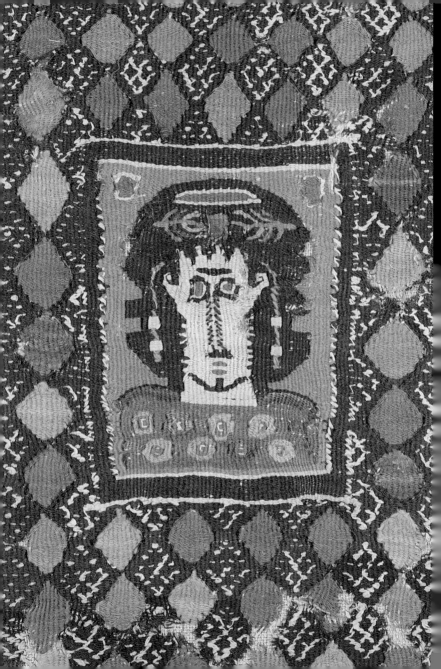

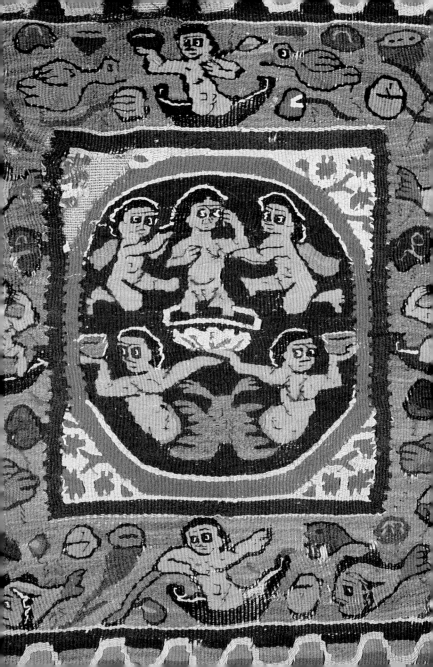

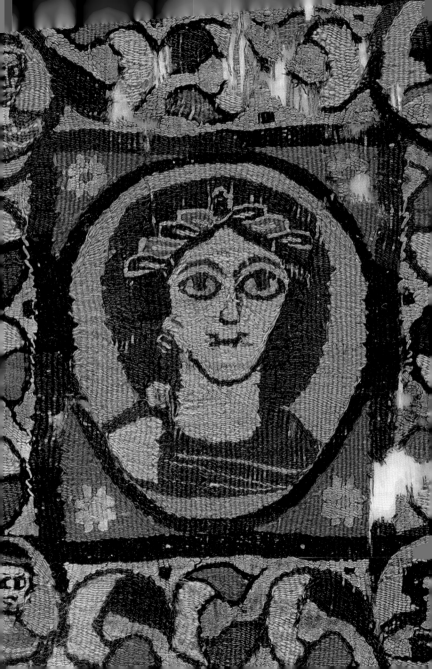

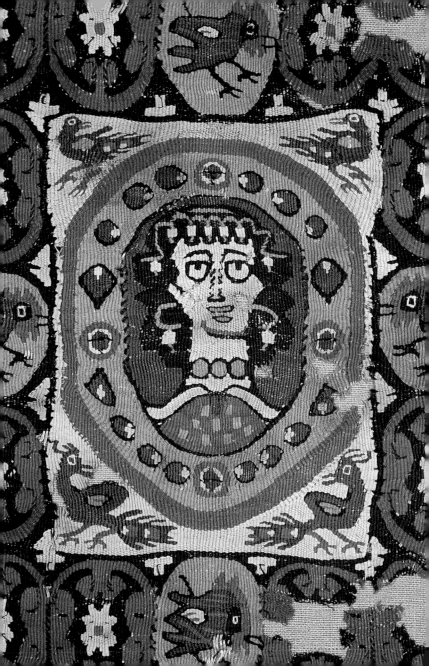

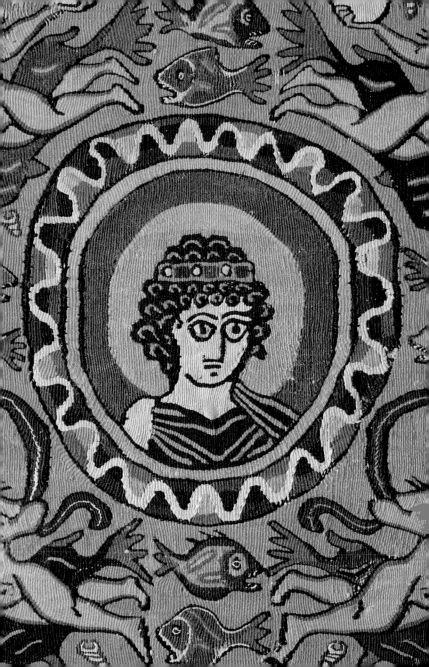

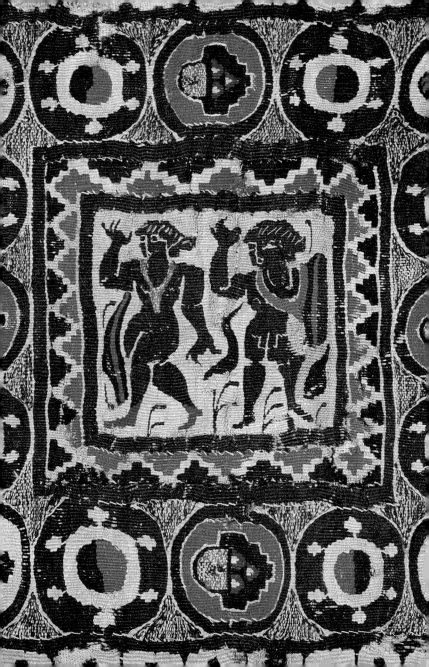

CONTENTS

COPTIC EGYPT
THE CHRISTIANS OF THE NILE

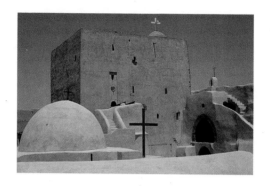

Christian Cannuyer

DISCOVERIES®
HARRY N. ABRAMS, INC., PUBLISHERS

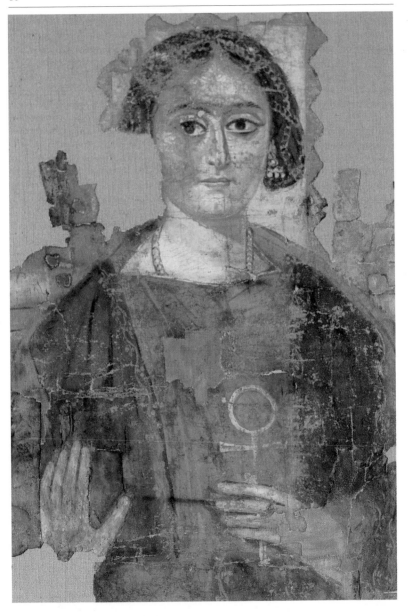

The Copts are the Christians of Egypt. Theirs is among the most ancient forms of Christianity, born in the time of Jesus. The name derives from the Arabic *Qibt,* an abbreviation of the Greek name *Aigyptios* (Egyptian); this in turn is a derivation of *Hikuptah,* House of the Energy of Ptah, the religious name for Memphis, the capital city of ancient Egypt. Coptic Christianity mingles remnants of pharaonic practices, elements of Hellenistic and Byzantine Egyptian culture, and the dynamism of Arab civilization.

CHAPTER 1
THE FIRST CHURCH OF ALEXANDRIA

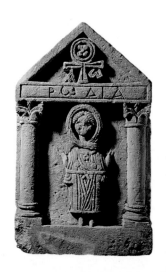

Left: a shroud depicting a deceased woman holding an *ankh* dates to c. 193–235. It bears witness to the survival of the practice of mummification among the early Christians. Right: the *ankh,* the ancient Egyptian emblem of eternal life, was adopted by Coptic Christians as their cross, known as the *crux ansata.*

The Greek historian Herodotus, writing in the 5th century BC, characterized the Egyptians of his time as "excessively religious, more so than any other people in the world." Indeed, for over three millennia the civilization of pharaonic Egypt centered on the cultural concept we call religion, even though the ancient Egyptian language has no such word. While all the civilizations of the Middle East were fundamentally religious, in Egypt religion was omnipresent in all human activity. Its optimistic vision of the world distinguished it from other ancient Near and Middle Eastern religious practices, as did the view, which dates to the era of the pyramids (c. 2600 BC), that death is not an end, but a new beginning, a passage to the next life.

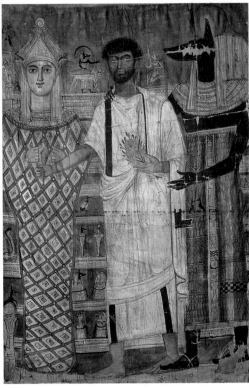

In the age of the pharaohs, God was close to humankind

The Egyptian religion had always revolved around the idea of divine unity. Despite its polytheism, by the time of the New Kingdom (c. 1550 BC), and especially after the failed religious revolution of the heretical pharaoh Akhenaten (r. 1352–1336 BC), the status of the gods had evolved profoundly. They had come closer to mortals and communicated with them more readily, especially by means of oracles, and they intervened in human lives as benevolent shepherds of the "sacred human flock." As this intimate relationship between deities and humans grew, the Egyptians developed notions of personal piety and mysticism that produced a significant body of spiritual literature, including prayers.

The Egyptians believed that the final destiny of human beings was to be resurrected as gods, specifically Osiris, associated with fertility and the afterlife. This belief was still alive when Christianity took root in the Nile Valley. Above: in this shroud painting, jackal-headed Anubis, principal god of the dead, introduces the deceased, a man in Roman garb, to the mummified Osiris at left.

The Egyptians gradually began to consider the gods in a different way. Beginning in the time of Ramses I (r. 1295–1294 BC), Amun, the great god of Thebes, became the most important among them. From this point on he was identified with Ra, the solar demiurge. In certain texts, Amun completely absorbs all the other gods; his omnipotence prefigures that of a single god, maker of history, who imposes his will upon human events.

The ancient Egyptian religion was far from dead when Christianity was born, around the time when the Romans conquered Egypt in 30 BC. A corpus of Hermetic Greek texts written in Alexandria reveals a philosophical interpretation of the pharaonic religion. Though they are from the same period as the New Testament Gospels of the Bible, they also preserve elements of the older beliefs of Egypt. Another source of information about religion in Egypt in the early Christian era is a text by the pagan Greek Neoplatonic philosopher Porphyry (234–c. 305), called *De abstinentia* (*On Abstinence*). This contains a description of ancient Egyptian priests that reveals how much they had in common spiritually with the first Christian monks, who were his contemporaries. An early form of Christianity called Gnosticism has come down to us in the famous manuscripts found at Nag Hammadi and other texts written by early Christians in the 1st and 2d centuries after Christ.

From paganism to Christianity

Thus the spiritual soil of Egypt was ready for the implantation of Christianity. There are striking similarities not only between the figures of Christ and

B elow: the pharaoh Ramses II (r. 1279–1213 BC) built many temples throughout Egypt. At Abu Simbel in Upper Egypt he appears in incised relief, worshiping the god Amun-Ra. This is the combined figure of the hawk-headed god Amun and the sun god, Ra, who became the preeminent Egyptian deity during his long reign. He was the supreme god, sole creator of the world, guide of history and shepherd of humankind. Priests in ancient Egypt embraced ideals that reflected his wisdom and goodness. Left: a statue from c. 300 BC of a priest of Onuris, god of war and hunting.

Amun, but also between Christ and Osiris, the Egyptian god of the underworld. According to Egyptian myth Osiris was murdered by his violent, jealous twin brother, Set; he was then resurrected and blessed with eternal life, symbolically promising victory over death for humankind. The parallel to the story of Christ is striking, lacking only the elements of the Incarnation and Crucifixion. The early Christians of Egypt were well aware of this connection; in naming the one true god of their faith they used the word *pnoute,* which derived from the term that had designated the deity in the ancient language of the pharaohs.

Renaissance authors of mythologies compared the god Osiris to Christ. The Egyptians themselves, in embracing Christianity, must certainly have noticed the parallel between these two figures, both of whom represent salvation and eternal life. Left: Osiris in an 18th-Dynasty tomb painting.

The profound religiosity of pharaonic Egypt appears to have thoroughly permeated the cultures that followed in its wake. Nevertheless, we must not overestimate the influence of that heritage on Coptic culture. It is limited to a few specific contributions and legacies, such as certain representations of the hereafter. "Egyptians are religious," Copts and Muslims like to say to this day. No doubt this is the principal legacy of the ancient civilization.

Coptic Christianity arose very shortly after the time of Christ, in an area of the world that had played a central part in the life of Jesus. If its earliest roots are in pre-Christian religious traditions, it can also claim to have been founded by one of the original Evangelists. The Copts have always been sensitive to the mysterious place their country holds in God's design, as expressed in the Bible, beginning with the earliest Jewish scriptures. Abraham lived in Egypt for a time; Joseph was Pharaoh's minister there; Moses "was trained in all the wisdom of the Egyptians" (Acts 7:22), and

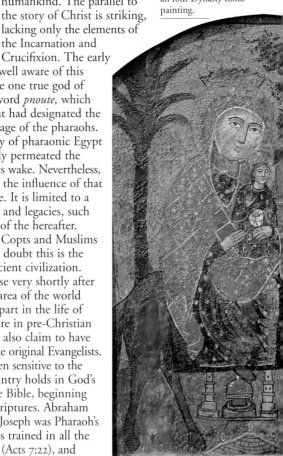

Isaiah promised, "The Lord will make himself known to the Egyptians. They will acknowledge the Lord when that day comes" (Isa. 19:21).

The Holy Family in Egypt

In "that day," Jesus found refuge on the banks of the Nile with his family, who were fleeing persecution at the hands of Herod the Great, king of Judea (Matt. 2:13–20). Egyptian tradition makes a great deal of the Holy Family's stay in Egypt; a number of sites along the Nile Valley commemorate their passage, the miracles performed by the infant Jesus, and the conversions he inspired. Many of these sites are object of passionate pilgrimages today. They include the Church of the Virgin at Daqadus; the church at Sakha, where an ancient icon of Mary is

venerated; the crypt of Musturud; the balsam tree at Mataria, known today as the Tree of the Virgin; and the monasteries of Gebel el-Tair (Mount of Birds) and Deir el-Muharraq, the latter built on the site where, according to tradition, Jesus gathered his apostles after his

Many episodes of the Old Testament take place in Egypt. Near left: the story of Joseph, who is said to have dreamed that the sun, the moon, and the stars bowed to him (Gen. 37:9), is represented on the central medallion of a 6th- or 7th-century textile found at Akhmim, in the middle Nile Valley. For the Copts, however, the privileged place held by their country in God's design is illustrated above all by the story of the flight there of the Holy Family. Center: an 18th-century icon from Deir el-Suryani (the Monastery of the Syrians) in the valley of Wadi Natrun, west of the Nile Delta. According to Coptic tradition, the Holy Family stayed in Egypt for three years and eleven months, which is consistent with the time between the presumed date of Jesus's birth (7 BC) and that of Herod's death (4 BC).

Among the Egyptians converted by the child Jesus, a text in the Apocrypha mentions a big-hearted brigand who supposedly bought some of the Holy Family's stolen belongings from his accomplice, in order to return them to their owners. Jesus met him again on Golgotha, for the bandit was none other than the Good Thief, who shared his Crucifixion.

⊤ΛΕ Χ̄ΑDRΙΑ·ΡΕRGΙΤ ΝΛVΙGΙΟΛΕΧ̄ΑDRΙ

resurrection to assign them the territories of their evangelical mission.

The apostolate of Saint Mark in Alexandria: legend or reality?

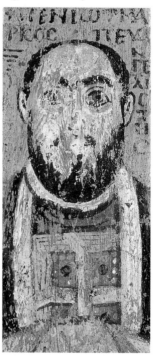

The new Christian faith is said to have been preached at Alexandria by Saint Mark the Evangelist, perhaps between AD 43 and 48. He is said to have died in the city on Easter in 62 or 68, lynched by worshipers of Serapis, a pagan god whose name and attributes are a composite of the Egyptian gods Osiris and Apis and the Greek gods Zeus, Helios, Hades, Asklepios, and Dionysos. A letter from Clement, bishop of Alexandria (c. 160–215), states that Mark came to Alexandria after the martyrdom of Saint Peter in Rome in 64 and there revised his Gospel in a more spiritual direction. There is some doubt as to the authenticity of this letter, but many scholars consider it reliable. Certain details of the Acts of Saint Mark (in the *Synaxarion,* a collection of ancient liturgical texts) seem to correspond to the topography of ancient Alexandria and especially to that of its Jewish quarters, where Christianity probably took root at a very early date.

Today, the leader of the Orthodox Coptic church is

The Egyptian period in the life of Christ, as recounted in the Bible, is not corroborated by any historical sources. It is nonetheless significant for the Copts, since it makes their country, together with Palestine and Israel, the Holy Land blessed by the presence of the incarnate Christ. Similarly, by tradition, the foundation of the Church of Alexandria is associated with the preaching of the Evangelist Mark. Left: a 6th- or 7th-century icon of Saint Mark as bishop of Alexandria.

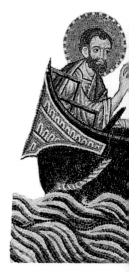

ADITCALIA MVRVP BSU
VITMANS SACSMARC

B elow: one of the seven
wonders of the ancient
world, the lighthouse at
Alexandria was built by
the Greek architect
Sostratus in c. 280 BC. In
this 13th-century mosaic
from the Basilica of San
Marco in Venice (which
once housed the body of
Saint Mark), the light-
house guides the saint's
boat to safe mooring at
Alexandria.

called the patriarch (or very frequently the pope), and
is still also considered the bishop of the See of Saint
Mark. The saint's body was pilfered from Alexandria by
the Venetians in 829. The relics were partially restored
to Egypt in 1968 by Pope Paul VI of the
Roman Catholic church, and today
are worshiped in the

Murqussieh, the great Cathedral of Saint Mark in the Abbassieh quarter of Cairo.

The first Christians of Egypt

There is little doubt that the first Egyptian Christians were Jews. Indeed, the largest community of the Jewish diaspora was in Alexandria, the great Greco-Egyptian trading city on the Mediterranean coast. Alexandria was the cosmopolitan metropolis *par excellence*—a melting pot in which the traditions of Greek thought, ancient Eastern religions, and new mystery cults all intermingled. It was there that the seventy scholars of ancient tradition had made the Septuagint, the first Greek translation of the Jewish Bible (also called the Alexandrian version), two or three centuries earlier. Around the year 50 Philo of Alexandria, a Hellenistic (Greek) Jewish philosopher, fashioned an allegorical reading of the Bible that was later adopted by Egyptian Christians. In it he described a community of Jewish ascetics, the Therapeutae, who lived some distance away from the metropolis in the semidesert district of Lake Mareotis. His narrative sheds some light on the lifestyle of these earliest Christian monks. According to the Acts of the Apostles (2:10) Jewish pilgrims from Egypt had taken part in the Pentecost in Jerusalem, going forth to preach the Christian Gospel after the first Easter. The apostle Paul, who died c. 65, had been born a Jew and was particularly interested in proselytizing to the Jews; he debated an Alexandrian Jewish preacher named Apollos, described in the Acts of the Apostles (18:24–28) as "knowing only the baptism of John," who had become a Christian "in his country."

Paul chose to bring the Gospel to the Jewish people, but did not himself go to Alexandria, probably because, we are told, "Christ was already named there" and he did not wish to "build upon another man's foundation," as he explained in his Epistle to the Romans (15:20–24). We may therefore surmise that by the year 50 a Christian community had grown up within the Jewish districts of the city.

Below: this 5th-century mosaic discovered in the house of the monk Leontius (c. 485–c. 543) at Scythopolis (now Bet She'an in Israel) illustrates the ties linking Palestinian Judaism with Alexandria. The city is represented by a Nile god, a leopard attacking an ox, a nilometer marking the height of the river during its floods, and, in the upper left corner, a schematic design of the great Synagogue, the Glory of Israel, in whose free intellectual climate an original form of Judaism blossomed. In the year 41 the Emperor Claudius (r. 41–54) urged the Alexandrian Jewish community—where Christianity was beginning to take root—to cease bringing their

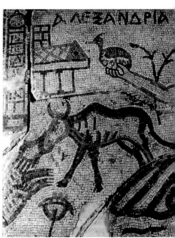

coreligionists over from Syria, for fear that trouble might arise.

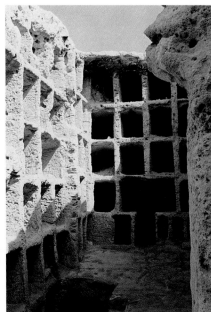

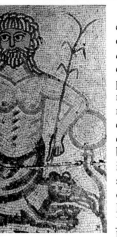

The administrative structure of the early church of Alexandria was based on that of Jerusalem: in both, the *episcopus,* or bishop, was elected by a college of *presbyteroi* (elders) and presided over it. Both organizations must have begun as Judeo-Christian mixtures; like Hellenistic Judaism, early Egyptian Christianity probably comprised a broad variety of sensibilities and theological opinions. This is perhaps one reason why we know so little about it. Viewed from the outside, Alexandrian Christians must have appeared scarcely different from Jews. Both groups were likely to have been victimized by the waves of anti-Jewish violence that shook Alexandria in the year 41 and again in 66 and 73, after the tumultuous Jewish Wars with the Romans in Judea. The martyrdom of Saint Mark

Above right: the communal tombs of the western cemetery of Alexandria, a famous necropolis excavated in 1997, were reused by Christians. Above left: crosses are painted on some of the *loculi,* individual niches 6½ ft. (2 meters) deep and 27½ inches (70 cm) high. Furniture from the 4th and 5th centuries was also found in the tombs, as well as pottery ampullae for holy water from the Monastery of Saint Menas, some 31 miles (50 km) southwest of the city.

in 62 or 68, in fact, may possibly be placed in the context of these upheavals.

The birth of Egyptian Christianity

The first known historical figure in Egyptian Christianity is Saint Demetrius, born in 126 and bishop of Alexandria from 189 to 232. Under his episcopate a Christian tradition opposed to the influence of Gnosticism came to prominence. This was the Catechetical School; two Greek Christians, the apologist Athenagoras (fl. 2d century) and the philosopher Pantaenus (fl. c. 180–200), figured among its early teachers. In 115–17 the Roman Emperor Trajan (r. 98–117) crushed a last revolt of the Alexandrian Jews, almost annihilating their entire community. Thereafter, the Jewish element faded, and by the 2d century the local Christian community seems to have been essentially Greek, at least culturally speaking.

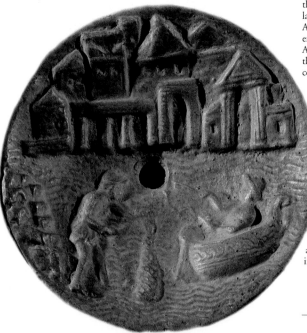

A bove: an Alexandrian drachma, coined in 109–10, displays a triumphal arch, symbol of the victories of the Emperor Trajan. Left: this 1st-century AD oil lamp shows the port of Alexandria, with two fishermen in the foreground. Among the buildings in the background is the conical tomb of Alexander the Great, who had founded Alexandria in 332 BC. In 117 the Jews of Alexandria rose up in revolt and were exterminated by Marcius Turbo, a general of Trajan.

"It is said that the Evangelist was the first man in Egypt to preach the Gospel, which he himself had written, and to establish churches in Alexandria itself."
Eusebius of Caesarea (c. 260–c. 339), *Historia Ecclesiastica,* vol. II, ch. 15

Did the near-disappearance of Alexandrian Judaism allow for the emergence of a clearly distinct form of Christianity in the city? The Christian faith was embraced by Jews and Greeks, but did it also reach the numerous indigenous Egyptians who lived in the Rhacotis quarter of the city? When did it begin to spread along the Nile Valley toward Upper Egypt? These are much-disputed questions, for which documentation is scarce.

Some scholars date the rise of Christianity among the Egyptian population along the Nile to the end of the 3d century, or perhaps the 4th. Nevertheless, the most ancient fragment of Gospel manuscript known to us, Rylands Papyrus 457, is paleographically dated to c. 130. It probably comes from the Fayum district of Middle Egypt, an area rich in archaeological discoveries, especially papyri. The Greek text is from John 18:31–33 and 37–38. Thus, by the early 2d century Christianity had clearly spread beyond Alexandria to other parts of Egypt. According to some later sources, Saint Demetrius established three bishoprics in the provinces of the Nile Valley in the 2d century. His successor, Heraclas (c. 180–248), is said to have created twenty bishoprics. Nine other biblical manuscripts of the 2d century have also been discovered in the Egyptian sands: three are passages from the New Testament. Several Christian papyri from this period bear marks indicating that they were used for communitarian and liturgical purposes; we may deduce therefore that there were already communities of Christians in the valley of the great river. May we not also presume, then, that despite the use of Greek as the common Christian tongue, some were indigenous?

The church between Gnostics and Manicheans

Despite these manuscripts and references, we know very little about the first two centuries of the church in

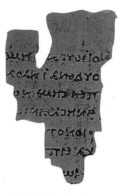

This fragment of a papyrus found in Egypt, known as Rylands Papyrus 457, is the most ancient extant piece of New Testament text. On the front (left) is a passage from John 18:31–33. Words and letters in italics correspond to the Greek terms actually preserved on the papyrus: "Then said Pilate unto them, 'Take ye him, and judge him according to your law.' *The Jews* therefore said unto him: 'It is not lawful *for us* to put *any man* to death': *That the* saying of Jesus might be fulfilled, which he spake, *signifying* what death he should d*ie*. Then Pilate *entered* into the judgment *hall* again, and called Jesus, *and sai*d unto him, 'Art thou the King of the J*ews*?' " On the back (right) is a passage from John 18:37–38, also with many gaps in the text.

Egypt. One influence was Gnosticism, a loose cluster of highly diverse beliefs that arose from the confluence of Platonic philosophy, Judeo-Christianity, and Asiatic dualistic religions. It reached Egypt in the late 1st or 2d century, probably from Syria-Palestine, and there produced some of its most famous teachers: Carpocrates, Basilides, Valentinus (who went to Rome to teach c. 136–60), and his disciple Theodotus. Gnosticism lasted until at least the 4th or 5th century, when the Gnostic manuscripts found at Nag Hammadi were probably transcribed. They are written in the Coptic of that period, though they are translations of older texts.

A dualistic Gnostic religion of Persian origins, modeled on Christianity, took root in Egypt in the late 3d century. Manicheism, named for its founding prophet, Mani (216–76), gives equal power to the forces of good and evil, the divine and the satanic. Roughly 2,000 Coptic Manichean manuscripts were discovered at Medinet Madi in 1929 and 1930, showing the vitality of the sect in the 4th century. Excavations at the Dakhla Oasis (known as Kellis in ancient times) since 1991 reveal the presence of a Manichean community there. The existence of this settlement suggests possible links among the Manichean and Gnostic communities and early Christian monasteries.

Some authorities think that there are so few records of the Egyptian church of the first two centuries after Christ because it was primarily Gnostic and heterodox, and orthodox Christians later suppressed or destroyed them. But while there were clearly Gnostic tendencies in early Egyptian Christianity, they were most likely not dominant. The beginning of the Christian era was an age of formation and research in which the church had not yet clearly defined the framework or administrative structure of its faith. Thus, many doors remained legitimately open. The Gnostics represented a formidable challenge to Christianity, particularly for the questions they raised concerning the "problem of evil" and of the presence of human suffering in the world. These were

Thanks to the Nag Hammadi manuscripts, the form of Gnosticism best known to us is a type notable for its unworldliness. The material world is opaque and evil, the perverse creation of a deceitful Demiurge, deliberately identified with the God of the Old Testament. Opposing it is the *pleroma,* the perfected world of the Light of the First Principle, or True God, tragically cut off by the fall of a divine spirit (called an *aeon*). This spirit is often associated with *Sophia* (wisdom), which gave birth to a grotesque abortion (the evil Demiurge). Above: the inner binding of Codex VII from Nag Hammadi.

and still are to be taken seriously, but as the church grew, it developed doctrines on such issues. Manichean and Gnostic creeds were declared heretical. Among the most ancient nonbiblical Christian manuscripts found in Egypt is a fragment of the *Adversus haereses* (*Against the Heresies*) by Bishop Irenaeus of Lyons (c. 115–202), a series of five books written entirely to combat Gnosticism.

The brilliant School of Alexandria

The struggle against Gnostic practices was partly responsible for the foundation in about 180 of the Catechetical School, commonly known as the School of Alexandria.

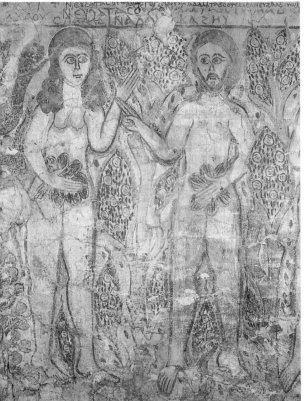

The Gnostics held that the evil Demiurge considered himself the Creator and made human beings by imprisoning souls (particles of light snatched from the *pleroma*) in flesh. These were subjected to the duality of the sexes, as illustrated by the story of Adam and Eve. Left: a painting from Um el-Baragat in the Fayum is influenced by Gnostic doctrine. It depicts Adam and Eve, encouraged by the serpent, eating the fruit of the tree of knowledge, and presents their condition as exiles from Eden as beneficial. Gnosis (from the Greek word for knowledge) consists principally in recognizing the captive condition of one's soul, so that one may liberate it and thus return to the Light whence humanity came. This knowledge can only be brought forth by an *aeon,* a savior who descends from the higher world. Jesus is such a savior, but he is not the incarnate Jesus of orthodox Christianity. He abolishes the law of the jealous God of the Old Testament and reveals the goodness of the "Father who art in Heaven," the God of the Beatitudes. To answer his call, Gnostics are required to sever all bonds with the material world, subject themselves to rigorous asceticism, and refuse to procreate.

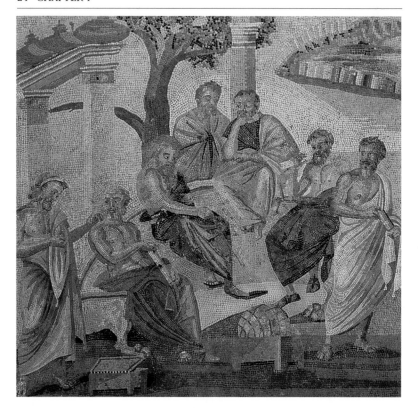

Some of the greatest authors of Greek Christian literature gained their fame in this milieu, including the Sicilian theologian Pantaenus, who is said to have traveled as far as India, and his disciple, Clement of Alexandria. Clement was director of the school from 200 to 203, then fled to Cappadocia to escape religious persecution at the hands of the Roman emperor Septimius Severus (r. 193–211). His aim was to put Greek philosophy at the service of Christian faith, and to make true Gnostics of Christians.

Perhaps the most illustrious of these early Christian philosophers was Origen (c. 185–c. 251), one of the most original and productive writers of Christian antiquity.

The School of Alexandria was less a formal university than a scholarly community gathered around teachers, much like the assembly of philosophers seen in this 1st-century AD Roman mosaic from Boscoreale, near Naples.

His name derives from the Egyptian, and means "born of Horus," the falcon god, son of Osiris. An intellectual descendent of Philo, he strove to demonstrate the superiority of Christianity over other religions and to this end offered an allegorical, mystical reading of the Scriptures. This sort of interpretation soon became characteristic of the School of Alexandria; its rival, the School of Antioch in Syria, favored a more literal biblical exegesis. After a disagreement with his bishop over questions of discipline, Origen left Alexandria in 230 to teach at Caesarea in Palestine (now Israel).

Saint Dionysius of Alexandria (c. 200–c. 265) led the school from 231 on. He became bishop in 247 and left behind a considerable body of theological writings. With the help of a mathematician named Anatolius, future bishop of Laodicea, he established the rules for calculating the date of Easter, which was to be on the first Sunday after the full moon following the spring equinox. These rules were eventually adopted by nearly the entire Christian world.

"God tempted Abraham and said unto him, 'Take now thy son, thine only son Isaac, whom thou lovest' " (Gen. 22:1–2). Why say not only "thy son," but "thine only son," and why add "whom thou lovest"? The biblical story of Abraham is among the most difficult in the Old Testament. God's continuous appeals to love and tenderness further intensify the pain of a father who is called upon to sacrifice his child. The living memory of this love, embodied in God, stays his hand. Origen writes, "All the legions of the flesh are marshaled against the faith of the spirit" (*Homily 8 on Genesis*). This homily examines the sacrifice of Isaac and reveals extraordinarily subtle powers of psychological analysis. Left: a 5th-century Coptic fabric shows the hand of God appearing from the upper left to stop Abraham, who is about to smite the boy.

From the Era of Martyrs to the Edict of Milan

The vitality and rapid spread of Christianity during this period can be measured by the violent persecutions it faced. The Roman emperors of the 3d century, commanding an immense and heterogeneous empire, were anxious to preserve its ideological unity by maintaining the established pagan religion. They felt that they had no choice but to combat the Christians, who stubbornly resisted religious conversion or assimilation. Egyptian Christianity bore the full brunt of Rome's escalating efforts to control and suppress the growing cult. An edict prohibiting the Christian faith was promulgated by Septimius Severus in 202 and led many Christians to martyrdom, including Origen's father, Leonides. Persecutions ordered by the Roman emperor Decius (r. 249–51) in 250 were worse still: in 251 Bishop Dionysius was forced to flee to the desert. Emperor Valerian (r. 253–60) in his turn also fulminated against the Christians in 257, and Dionysius was exiled to Libya, where he began to preach the Gospel.

In 259 Emperor Valerian's son and co-emperor, Gallienus, issued an edict of tolerance that allowed the church a respite. The process of evangelization promptly picked up speed and Christianity soon swept into Egypt as far south as the province of the Thebaid and modern Luxor. But Christians remained a minority in the country as a whole, and it is difficult to determine the extent of their influence. All the same, by the start of the 4th century 72 communities in Egypt were large enough to have a bishop. These included 18 in the Thebaid, 7 in Cyrenaica, and 8 in what is now lower Libya.

This first period of tolerance came to an end in 303–4, when Emperor Diocletian (r. 284–305) published four edicts of persecution that struck all of Eastern Christendom with tragedy. The church in Egypt was so utterly devastated that it later chose the start of this tyrant's reign as the first year of a time called the Era of Martyrs. To this day, Coptic spirituality and identity are imbued with the memory of the men and women who died for their faith in the ancient world. Copts may even, at times, embrace a kind of obsession with martyrdom, exacerbating their conflicts with Islam.

Diocletian abdicated the throne in 305, and a short

A soldier in the service of Rome named Menas was apparently executed for his Christian faith at Alexandria on November 11, 296, and became Saint Menas (Abu Mina in Coptic). He is said to have asked that his body be placed on a camel and sent out into the Libyan desert to be buried at the spot where the camel halted. Right: in this 6th-century statue he raises his arms in prayer, flanked by camels. Around 324 the Roman empress Helena (c. 248–c. 328) erected a shrine upon his grave in the desert south of Alexandria, after her daughter had been cured of elephantiasis by drinking from a nearby spring. In the reign of Emperor Arcadius, who ruled the eastern half of the Roman Empire from its partition in 395 to 408, the shrine was expanded into a splendid basilica and monastery. It became one of the most frequented pilgrimage centers in all Christendom.

period of calm followed. But the church was soon beset by a schism, brought on by a quarrel between the intransigent Bishop Meletius of Lycopolis and the more tolerant Peter of Alexandria (bishop, 300–311), who was lenient toward Christians who denied their faith under torture. The Meletian church was well-established, and prospered until the end of the 4th century and beyond.

In 310–12 Emperor Maximinus Daia (r. 305–13) redoubled the anti-Christian persecutions, beheading Peter himself. But in 313 the Edict of Milan, issued by Emperor Constantine I (r. 306–37), effectively freed all Christians to worship openly, and forever altered the fate of the religion.

The earthenware ampullae of Saint Menas, in which worshipers transported miraculous spring water, are found at many ancient sites. This one bears an image of Saint Thecla, a 1st-century AD disciple of Saint Paul and an early martyr. According to the Apocrypha, she was thrown into a field with ferocious beasts, but escaped miraculously. She is shown here with hands bound behind her back, flanked by bulls, a she-bear, and a lioness. An oratory was dedicated to her at the Alexandrian port of Dekheila, near the

Monastery of Saint Menas. During the Coptic patriarchate of Christodulous (r. 1046–77), her relics began to be venerated on an island in the Nile Delta.

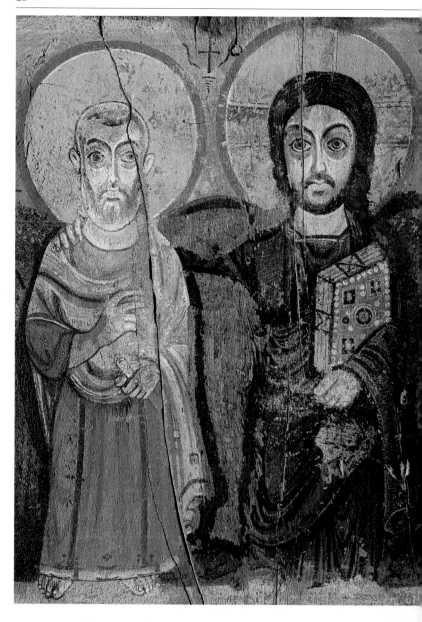

From the 4th to the early 7th century, Egypt was part of the Eastern Roman Empire (later called the Byzantine Empire), where Christianity became the state religion after 391. The Egyptian church was at the center of the period's great controversies about the nature of Christ; after the Council of Chalcedon in 451 it broke away from the churches of Rome and Constantinople in a dispute about the doctrine of the conception of Christ as both mortal and divine. Meanwhile, in the Nile Valley monasticism developed in a variety of forms.

CHAPTER 2

WHEN EGYPT WAS CHRISTIAN

Left: this famous panel, painted in the 6th or 7th century, depicts Christ the Savior embracing the Abbot Menas, the prior of the Monastery of Saint Apollo at Bawit. It evokes the close alliance between Egypt and the Coptic church at this time. Right: a painting of a cross from Kellia.

In the 4th century the Roman emperors exhibited a new benevolence toward Christianity, eventually embracing it. Egyptians converted in large numbers. Bishoprics multiplied until there were about 100. The church attracted masses of peasants who sought protection from the arbitrary exercise of power by the secular authorities, and succor from poverty.

Saint Athanasius, champion of the Nicene Creed

The first great controversy to descend upon the church of Alexandria concerned the nature of Christ. Around 318–23 the theologian Arius (c. 250–336), a church elder in the Bucalis quarter of the city, publicly questioned the established belief that God and Christ were of one and the same substance, and that Christ was both human and divine. This was the concept of Christ as the Logos, or Word of God made flesh. Arius was challenging Alexander of Alexandria, bishop from c. 312 to 328, who argued that the two were eternally coexistent and made of the same substance. To Arius this view suggested a belief in more than one God. He theorized that God was ultimately an uncreated, unknowable, and separate being, and thus Christ could not be equally eternal with God, but was created by him.

A heated debate ensued, pitting the beliefs of Arius and his followers against Alexander and the local clergy. In 324 the Egyptian and Libyan bishops excluded Arius from communion services. But elsewhere in the Mideast, other groups like Arius's were forming. Responding to the agitation caused by this affair, the Roman emperor, Constantine I, summoned an ecumenical council in

Around 347 Saint Athanasius consecrated the young Syrian bishop Frumence, who then converted the king of Ethiopia, Ezâna, to Christianity. The Church of Ethiopia (depicted in the cross below) came under the control of Alexandria and had an Egyptian archbishop until 1959. Below left: a painting of Athanasius from the Monastery of Saint Anthony of the Desert, near the Gulf of Suez; below: a 19th-century Ethiopian cross.

the city of Nicaea (now in Turkey) in 325, in an attempt to unify Christian beliefs and develop a single accepted doctrine. At the council Bishop Alexander and his deacon, Athanasius (c. 293–373), presided over an assembly of more than 300 ecclesiastics. The council solemnly proclaimed the creed that Christ, the Son, was the "true God, issue of the true God, engendered and not created, consubstantial with the Father." Arianism was declared a heresy. Athanasius became bishop of Alexandria upon the death of Alexander in 328; during the course of his tumultuous life he became the passionate champion of the Nicene Creed and of the doctrine affirming that Christ was fully one with God (*homoousios,* or consubstantial, of the same substance).

But this term had no foundation in the Scriptures and many bishops in Asia came to oppose it. In their eyes it did not sufficiently distinguish between the persons of God and Christ. From 326 to 381 the Arian crisis tore the Eastern churches asunder, with complex repercussions. Athanasius, supported by his monks, went to Rome to defend Nicene orthodoxy, while in the East the anti-Nicene faction grew powerful, and was supported by the emperors, beginning with Constantine himself in 328. Athanasius was deposed and exiled five times and almost lynched during a riot in 356. When he died in 373 Nicene faith regained ascendancy through the political and theological actions of Basil the Great (c. 329–79), bishop of Caesarea, an ancient seaport in Cappadocia (now Turkey).

When Theodosius I (r. 379–95), a devoted follower of the Nicene Creed, seized the Roman imperial throne in 379, he brought about the end of Arianism. He was supported by the Damascene bishops and Peter II of

The second Ecumenical Council was convened at Constantinople in May 381. There, some 150 bishops reaffirmed the Nicene Creed, bringing the Arian crisis to a close and proclaiming the divinity of the Holy Spirit. Despite protestations by Timothy I, bishop of Alexandria (brother and successor of Peter II), the third canon of the Creed specified that "the bishop of Constantinople has primacy, after the bishop of Rome, for this city is the new Rome." Above: the council depicted in a Greek miniature in the *Homilies* of Gregory of Nazianzus, c. 510.

Alexandria (bishop from 373 to 380). A second ecumenical council, held at Constantinople (now Istanbul) in 381, confirmed the Nicene Creed, specifying that the Holy Trinity was composed of a single essence (*ousia*), but three persons (*hypostases*). A council met again at Ephesus in Turkey in 431 and a fourth time at Chalcedon, near Constantinople, in 451. There it raised the status of Constantinople, the capital of the Eastern Roman (Byzantine) Empire, by placing its bishop second in honor only to the bishop of Rome. Alexandria, which had

According to legend, Saint Paul of Thebes (c. 230–c. 343) lived to the age of 113; he is considered the first Christian hermit. Toward the end of his life, Paul met Saint Anthony, who was present at his death and buried him in a grave dug by lions. Below: a 1777 icon of Saints Anthony and Paul.

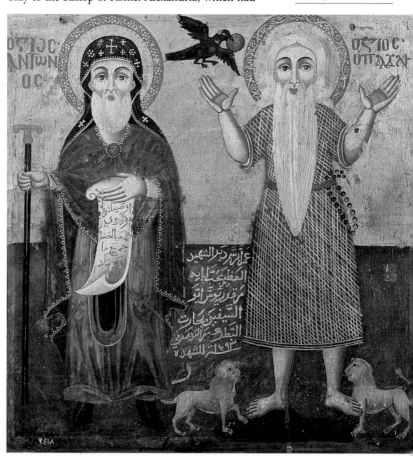

formerly occupied second place after Rome, did not look favorably upon its displacement.

The birth of monasticism

Well into the 3d century, persecution of Christians by the Roman emperors remained frequent. Some individuals sought refuge from harassment in desert settlements where communal worship was practiced, while others chose to live in solitude as hermits or anchorites (the word is from a Greek term meaning "to withdraw physically"). The impulse to seek solace in the desert was an ancient one in Egypt, with origins in the Ptolemaic period (323–30 BC). It gave birth to the worldwide Christian tradition of monasticism.

One of the most famous desert hermit saints was Anthony (c. 250–355). He chose to retreat from society around 270, not to escape persecution, but from religious fervor. The call of Jesus "to sell all that thou hast" (Luke 18:22) had brought about a deep inner conversion in him and drew him to a solitary life. Anthony and the other early hermit saints came to be known as the Desert Fathers; for them the desert represented a quest for evangelical poverty, a desire to return to the intact purity and first innocence of earthly paradise. According to some texts, many hermits lived naked, spoke with wild beasts, and reached an astounding age. Their isolation also symbolized a passionate belief in Christ's return. The hermit's life was an absolute break with the world: a rejection of sexuality, pleasure, and human society, in pursuit of the essence of spirituality.

To escape the Decian persecutions, Paul of Thebes fled into the Egyptian desert of the Thebaid in about 245. There, Saint Jerome tells us, he transformed his "state of necessity into a deliberate choice," dwelling alone in a cave and living a life of austere contemplation. He is the embodiment of the most extreme anchorite. Below: desert hermits in a medieval Byzantine manuscript.

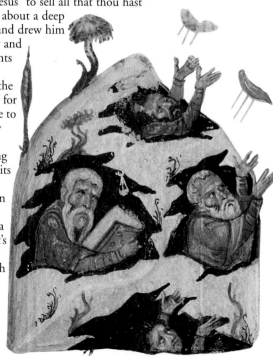

Anchoritic monasticism

Saint Anthony undoubtedly saw that there was some danger in a radical renunciation of the world, for it led to misanthropy and, ultimately, the betrayal of evangelical charity. Around 305 he abandoned his pure hermit life and accepted disciples. He began to live communally with a group of followers; from this project anchoritic monasticism was born. He drafted rules of conduct for the group, based on the concept of spiritual paternity. The young anchorite or monk (from the Greek *monachos,* meaning "celibate") lived in a monastery or hermitage, a secluded place of residence, with an elder who served as a role model. Individual ascetic hermitages, scattered throughout the desert, soon formed small colonies, each headed by a hermit monk who administered the sacraments and read the Sunday liturgy. The nucleus of every monastery was its church and a building for the weekly

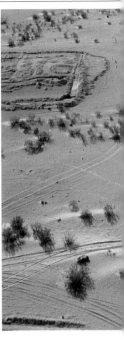

communal meal; later, a workshop or storehouse for products made by the community was often added.

The formula met with rapid success: the best-known anchoritic colonies were those of Nitria and Wadi Natrun, to the west of the Nile Delta, founded in c. 325–30 by Ammonas and the ascetic Macarius the Great (c. 300–c. 390); and Kellia, founded by Anthony and Ammonas in 338. There were many other settlements in the Nile Valley, not only in the desert but also within the ruins of ancient pharaonic temples or near towns.

L eft: a private oratory with three niches was discovered in 1982 in Qusur al-Rubayat, at Kellia. Two crosses frame the central niche, which has a shelf supporting two attached columns with Corinthian capitals, painted to imitate stone fluting. The archivolt is a series of triangles decorated with a floral motif. The interior of the niche is decorated with shell and vine motifs. Below the shelf is a triangular arch decorated with a braid motif in white on a Pompeiian red ground.

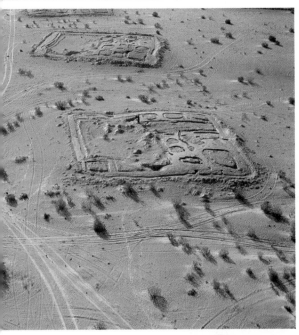

Left: the 6th- and 7th-century site known as Kellia was rediscovered in 1964. It comprises some 1,500 monk's dwellings scattered over nearly 40 square miles (100 square km). Excavations have revealed much information about the structure of hermitages in the period just before the Arab conquest. Those at Kellia are mostly of medium size (82 x 115 feet, or 25 x 35 meters), designed for two or three residents. Each was surrounded by a wall that granted the monks privacy. Below: a reconstruction of such a dwelling. The courtyard had a well and latrines in the southeastern corner, sheltered from prevailing winds. The main building, at the northwest corner, had a vestibule giving access to the monk's chambers.

Contrary to popular belief, monasticism was not an exclusively rural phenomenon; in fact, for reasons that were in part economic, most monasteries were not far from cities. This allowed the monks to sell their products and earn a minimal subsistence. There were small numbers of female monks, or nuns, too; the founding texts of the Desert Fathers, the *Apophthegmata,* show us a few rare portraits of so-called Desert Mothers. Cloistered monasteries where women resided were by rule found only within city boundaries.

The Cenobitic Rule

A Christian monk named Pachomius (c. 290–346) is traditionally credited as the founder of cenobitic, or

Adjoining this were the chapel, kitchen, pantry, and the room of a servant or disciple. Despite their austerity, these hermitages had amenities. They do not quite match the severe picture that the written sources convey of the life of the first Desert Fathers.

"There are thousands and thousands of cells carved into the rocks in the most inaccessible places. The anchorite saints could reach these caves only by way of very narrow paths, often blocked by precipices, which they crossed on small wooden bridges that could be removed on the other side, making their retreats inaccessible. This was called the Thebaid, an area once famous for the prodigious number of hermits who lived there…There are also deserted mountains running toward the Red Sea, three or four days' march away, and these are properly the deserts of the Thebaid so celebrated in ecclesiastical history. There, between the Suez and Mount Qulzum, at a distance some six or seven leagues from the Red Sea, one sees the famous Monastery of Saint Anthony of the Desert, the grotto of Saint Paul, and various other similar retreats, made sacred by the penitence of ancient anchorites." This account is from a 1735 text by the French diplomat Benoît de Maillet, *Description de l'Egypte* (Description of Egypt). Left: a scene of the cave-dwelling hermits of the Thebaid, as imagined by the Florentine painter Fra Angelico around 1420, conveys the West's idea of Egyptian monasticism.

communal, monasticism, which combined religious asceticism and the private search for inner spirituality with the pleasures of sharing life with other like-minded people. Pachomius was raised a pagan and converted to Christianity during his service in the army; this gave an added dimension to his religious perspective. He first became an anchorite; then, after seven years, around 323 he founded a community in Tabennisi, in Upper Egypt.

Below: the Monastery of Saint Anthony of the Desert at the foot of Mount Qulzum, near the Gulf of Suez, was built on the site where Anthony lived. In the foreground is the 3d-century Church of Saint Anthony; in the background, that of the

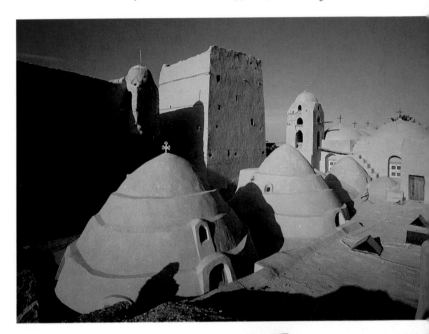

This so-called *cenobium* (derived from the Greek *koinos bios,* or "common life") functioned according to certain simple principles: one was expected to show respect for others; maintain the purity of one's own body and spirit; keep a frugal lifestyle, alternating work and prayer; and find a balance between solitude and communion. These regulations were codified in a text called the Cenobitic Rule, or Rule of Pachomius.

Cenobitism differed from the partially communal

Apostles, built in 1470; at left are the treasury and the *qaçr,* or defensive keep. Monasticism continues to flourish here today.

anchoritic sects mainly in its organization. Its structure was manifested on many levels, from its strict architecture, with a great wall enclosing thirty or forty houses (each ideally occupied by forty monks), to its daily program of prayer, work, and meals. At his death, Pachomius had established nine such monasteries for men and two for women, each administered by a principal monk. His disciples Theodore (d. 368) and Horsiesi (d. c. 380) continued his work and founded cenobitic monasteries all over Egypt. By the year 400 there were thousands of cenobitic monks; the success of these thriving communities contributed to the decline of paganism. The Rule of Pachomius was brought to Europe by Saint Jerome around 384; it was the basis and inspiration for the later Rule of Saint Benedict of Nursia (c. 480–547), an Italian hermit who established numerous monasteries in the region east of Rome, and who is often called the father of Western monasticism.

But we should not be misled; in Egypt Saint Anthony's monasticism enjoyed a more lasting success than the cenobitic form, which disappeared after the Arab conquest in 642. Soon a mixed form of monasticism developed, combining elements of both. Such a monastic settlement has been excavated at Deir Naqlun, in the Fayum. In the 6th century it included a church, monks' cells, administrative buildings, and a defensive keep. Close to ninety monasteries were scattered through the mountain caves and along the canal that served the oasis. Another large site is in Kellia, which had colonies of individual hermits and semi-cenobitic monasteries, whose monks lived either communally or as hermits, some permanently, others temporarily. This system is still found today in monasteries in Wadi Natrun and along the Red Sea.

Below: an icon of Saint Pachomius, based on a medieval wall painting in the Monastery of Saint Macarius. Pachomius was born in Esna, in Upper Egypt, of peasant parents who schooled him in "Egyptian letters." He enlisted in the army of Maximinus Daia in 312. He then became a hermit under the instruction of the elder hermit Palemon (d. 323), upon whose death he founded his first monastery. His brother, John, and the provincials of the surrounding area joined him in building another hermitage for his sister, Mary. In the 5th century Abbot Shenute lived in one of the greatest Cenobitic establishments, Deir el-Abiad, the White Monastery, far up the Nile near Sohag. He reformed Cenobitism by instituting the rule of obedience. Left: the ornate key of the White Monastery.

A developing administrative structure

In 391 or 392 Emperor Theodosius I (r. 378–95) outlawed paganism. Theophilus, patriarch of Alexandria at the time, commanded the destruction of the Temple of Serapis there. A symbol of the ancient world was toppled, along with the 4th-century BC statue of the pagan god by the Greek sculptor Bryaxis. The church had triumphed, but its victory was not sweet, for it went from persecuted to persecutor. Theophilus and his nephew and successor, Cyril (376–444), pursued a violent course of suppression of pagans and heretics. Although the bishops objected to the aggression of Cyril and his followers, they could do little to stop it. Sanctuaries were leveled and lynchings occurred. Among those murdered was the pagan Neoplatonic philosopher Hypatia (c. 370–415), known for her intelligence and beauty, who was killed by a Christian mob. Cyril's passionate support for Christianity drove him to persecute many religious groups, including Jews, who were expelled from Alexandria in 412.

As bishop of Alexandria, Cyril governed the city's large Christian population and championed their faith; his enemies called him pharaoh, because he was despotic. Under the sixth canon of the Council of Nicaea, he became internationally powerful. He was the undisputed master of the episcopates of Egypt, Libya, and the Pentapolis (a cluster of five ancient cities), without the intermediate archbishops who were in place in other countries. He had the privilege of choosing and consecrating bishops.

In the 5th century the Christianized Roman Empire swiftly developed a hierarchy. The cities and lands were divided into episcopates, each governed by a bishop. Within these were the dioceses and parishes, each with its priest. The bishops generally came from wealthy families and now occupied positions in the upper circles of society.

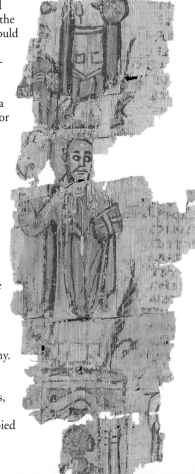

This fragment is from a Greek manuscript called *The Alexandrian Chronicle*, thought to be from the 8th century. It depicts Patriarch Theophilus in Alexandria, standing triumphantly among the ruins of the pagan temple called the Serapeum, which he has destroyed.

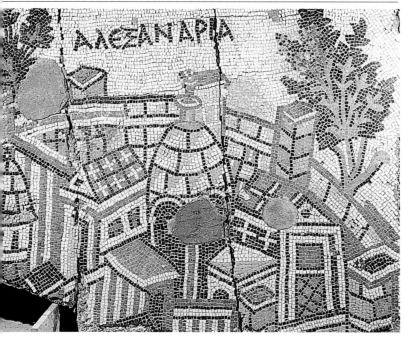

ΑΛΕΞΑΝΔΡΙΑ

They enjoyed a great deal of autonomy, which increased the farther they were from the capital, Alexandria. Furthermore, they rarely gathered together in synod. Assistance to the poor, widows, and the sick was a priority, and to this end they had at their disposal the income of the diocese.

Throughout Egypt it gradually became the custom to recruit bishops from among the growing population of monks—the first known cases, between 339 and 345, being Philo of Thebes and Muizz of Latopolis, men known for their benevolence and piety. In this way the principle of celibacy was slowly imposed in the East, for until then Coptic priests, unlike their Roman counterparts, had been permitted to marry, with the exception of those who were monks and lived in monasteries. As for the parishes, their priests and deacons were organized according to a complex hierarchy and chosen and ordained by the bishops. Parishes multiplied more

Christian Alexandria rapidly filled with churches. This 6th-century Jordanian mosaic shows one area of the city with its many domes. The oldest church was built by Theonas, bishop from 282 to 293, and dedicated to the Virgin Mary by Bishop Peter II. It was the original cathedral, soon replaced by the Great Church, which was the former Caesareum, the Greco-Roman temple dedicated to Caesar Augustus. This was deconsecrated in 313, given over to the Christians, and reconsecrated in the new faith.

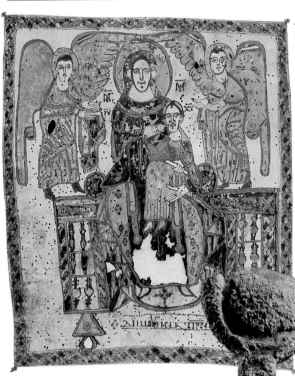

As early as the 2d millennium BC, the goddess Isis was worshiped in Egypt as the "Mother of God" (*Mut Netjer*). She is shown in ancient murals and statues with her son Horus, called "Savior" for having avenged his father's death. In the 4th century BC the cult of Isis spread across the Mediterranean basin as far as Gaul (modern France). In Egypt it survived until 537, when the temple of Isis at Philae in central Egypt was desecrated by Emperor Justinian. Below: depictions of the goddess suckling the Child Horus (*Isis Lactans*), such as this 7th-century BC bronze statue, influenced later Christian iconography. Left: Byzantine artists sometimes mingled remnants of pagan thought with Christian faith, as in the rare *Galaktotrophusa* icons, called in Latin *Maria Lactans*, in which the Virgin Mary nurses the Infant Jesus. This miniature from a c. 892 Christian manuscript is an example.

quickly in the villages than in the towns, where the bishops preferred to manage affairs directly.

Honoring the Mother of God

Cyril proclaimed his authority at the Council of Ephesus in 431, unjustly deposing and exiling Nestorius, patriarch of Constantinople. The point of disagreement between the two clerics was a doctrinal question of the status of the Virgin Mary. Nestorius refused to use the epithet *Theotokos*

(Mother of God) when referring to the Virgin, fearing that this encouraged confusion between the divine and human natures of Christ. Cyril favored the term. For him, if Jesus was God, then Mary was the mother of God, for Christ is one: he has but one nature; his humanity cannot be separated from his divinity.

Although this epithet had appeared in Egyptian Christianity at the beginning of the 3d century, its roots were older and pagan. The ancient Egyptian goddess Isis was worshiped well into the Hellenistic epoch; her cult was celebrated on the Nile island of Philae, where Ptolemy II (r. 285–46 BC) built a temple in her honor that continued in use until the 6th century. Because she was mother of the god Horus, she was called "mother of god," after the manner of goddesses in the ancient pharaonic era.

The Council of Chalcedon

In Constantinople a monk named Eutyches (c. 378–c. 450) developed Cyril's ideas in a way that Cyril would not have approved: he argued that within the unity of Christ, his humanity had been absorbed by divinity. A local council, presided over by Flavian, bishop of Constantinople from 447 to 449, condemned Eutyches's theories. Dioscorus, a Greek prelate who served as bishop of Alexandria from 444 to 454, felt that this judgment was an unjust condemnation of Cyril's theology. With the support of Emperor Theodosius II (r. 408–50), he organized a second council in Ephesus, on the west coast of Turkey, in August 449. There, Eutyches's ideas were supported and Flavian's rejected. Dioscorus expressed Eutyches's concept of the nature of Christ as "a single *physis* [concrete individual nature] of the Logos and God

theodosius iunia imprisimodus epp̄
que cc scī patris cū imperatore con
uenune et subscripserunt.

In 431 Emperor Theo-dosius II convoked the Council of Ephesus to debate and resolve the Nestorian controversy, concerning the status of the Virgin Mary. The sessions were primarily led by Cyril of Alexandria, who condemned and deposed Nestorius in a single day (June 22), before the arrival of the Eastern bishop, John III of Antioch, and the papal legates, who supported him. Despite protests, appeased by imperial authority, Cyril was triumphant: Mary was proclaimed Mother of God at Ephesus, a city sacred in antiquity to the goddess Artemis, virgin and mother.

incarnate," which did not deny the humanity of
Christ. Yet the logic of this conception of Christ was
incomprehensible to the people of Constantinople. The
Roman pope, Leo I (r. 440–61), agreed. In June 449 he
wrote a famous "Dogmatic Letter" to Flavian that spoke
of two natures, human and divine, in the Word
incarnate. In other words, Christ has two distinct
natures, both of which are
essential. His nature is an
abstraction: two united in one.

Contrary to what is often believed, the Copts never embraced the Monophysite heresy.

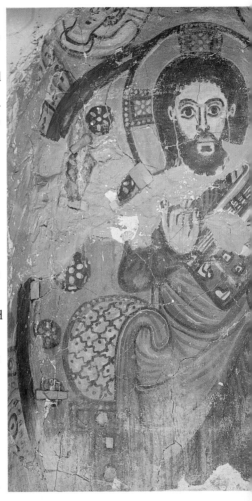

In reality, what was meant
by *physis* in Alexandria had
little to do with what the word
conveyed in Constantinople,
or in Rome, where its counter-
part was the Latin word *natura.*
Dioscorus had led the council
of 449 with a strong arm, just
as Cyril had done before him.
His outraged adversaries
responded: under a new
emperor, Marcian (r. 450–57),
they convoked a counter-
council in 451, the Council
of Chalcedon. There they
condemned the patriarch of
Alexandria, and, taking up the
formula of Leo I once more,
described Christ as having a
unity of person (*hypostasis*) and
a duality of natures (*physis*).

In Egypt, opposition to the
Council of Chalcedon was felt
immediately, especially in
monasteries, which drove out
most Chalcedonians. The
reaction against Chalcedon
was expressed as hostility to
the Greek church of Con-
stantinople and Byzantium in
general, which was abhorred
for its harsh economic system.

Some scholars see in this an expression of a nascent Coptic nationalism, opposed to Greek culture, but there is little to support the idea. Chalcedonians were found among Egyptians of both Greek and indigenous race, and the use of Greek in the Coptic church flourished until well after the Arab conquest in the 7th century. After Dioscorus, the church of Egypt became known as Monophysite, that is, acknowledging a single *physis* in Christ. The term was pejorative, indicating a heresy, and the later Copts rightly rejected it. Today we speak, rather, of the pre-Chalcedon church in Egypt.

The period of the religious councils in the 5th century was a difficult and defining moment for Christianity. In trying too hard to plumb the mystery of Christ, both true god and true man, at a time when theological terminology was not yet unanimously defined, the churches of the new Christian world became entangled in an unwinnable debate and split by factions, which were aggravated by political and cultural dissent. They shared a common source of their ideas and a belief in the same Christ, but they did not know it.

A persecuted and divided church

Repression of the Egyptian church by the Roman emperors gave way to a politics of appeasement. In 482 the Byzantine Emperor Zeno (r. 479–91) issued a document, called the *Henoticon*, that offered a compromise between the Monophysites and what was now coming to be known as the Orthodox church. This proposed to omit the phrase "two natures" from all descriptions of Christ's life and works. But the more radical of the Monophysites rejected the concession, and it was eventually rejected by Rome and the

Left: this detail of a mural from the Monastery of Saint Jeremias at Saqqara represents Christ in Glory, with his right hand raised in a gesture symbolizing the union of his divine and spiritual natures. The position of the thumb and ring finger of the right hand also symbolizes this, as does the red color of his tunic. The ornate mandorla (almond-shaped nimbus) and the jeweled halo encircling his head signify his divinity as well. The Coptic Liturgy of Saint Basil says that the Eucharist is "the life-giving Body of…Our Lord, our God and Savior Jesus Christ; begotten of Our Lady and Queen, Saint Mary, Mother of God. He made it one with his divinity, without mixture, without confusion, and without change…I believe, verily, that his divinity has never been separate from his humanity, not even for a moment or the blink of an eye." No statement of the unity of Christ's dual nature could be plainer. Now that history has taken its course, Christians who engage in ecumenical dialogues regret the ancient quarrels among Chalcedonians, Monophysites, and other churches; in 1973 the Coptic and Catholic churches signed an accord that recognized their common faith in Christ. Accords were reached with the Orthodox churches in 1989.

most resolute Chalcedonians as well. The accession of
Emperor Justin I (r. 518–27) put an end to the period
of reconciliation. Nevertheless, Egypt, where a large
number of Monophysites lived, remained relatively free
of violence during this turbulent period. A brilliant
theologian, a non-Chalcedonian Greek named Severus
of Antioch (c. 465–538), took refuge in Egypt at this
time, and remained there to expound and develop the
ideas of Cyril.

From 540 to 578 the church of Egypt was torn apart
by incessant theological controversies, made worse by
the repressive politics of Emperor Justinian I (r. 527–65),
who exiled Patriarch Theodosius to Constantinople.
More than twenty rival sects arose, and the ongoing
quarrels about the nature of Christ became fixated on
differing concepts of the Trinity. This situation affected
the ecclesiastical milieu, particularly in Alexandria.
However, it did not diminish the vitality of
Christianity itself in Egypt; monasticism
especially continued to flourish.

A patriarch of Syrian origins, Damian
(r. 578–605), succeeded in bringing concord
to the Egyptian church and reconstructing
its hierarchy, which had been seriously
weakened by years of crisis. His
successor, Anastasius (r. 605–16),
succeeded in reestablishing ties with the
Monophysite church of Syria (called the
Jacobite church), after a rift that had
endured for half a century.

In 618 the Persian king Khusraw II
invaded and occupied Egypt. Although
this was initially traumatic, the con-
quering Persians proved tolerant of the
Copts, whom they favored. In 629 the
Byzantine Christian emperor Heraclius
(r. 610–41) reconquered the country and
ousted the Monophysite patriarch
Benjamin (620–62), who fled to Upper
Egypt. Heraclius named a foreigner,
Cyrus, as patriarch, granted him far-
reaching powers, and commanded him

"Hail to the Cross, tree
of Paradise whose per-
fumed branches give life
to all. Hail to the Cross,
symbol of Health, which
Constantine saw shining
in the sky. Hail to the
Cross, luminous golden
chandelier on which burns
the lamp of Emmanuel."
An early medieval
Coptic hymn

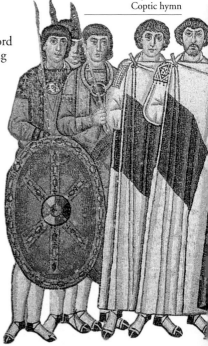

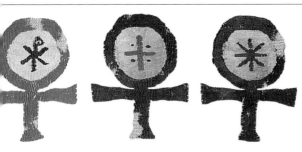

to promote monothelitism, a theological compromise that recognized two natures in Christ, but only one will.

The influence of religion on Coptic literature

Beginning in the 3d century, the young church had resisted assimilation into the general culture of Egypt. At that time the first examples of a Christian literature written in the Coptic language appeared. Coptic was

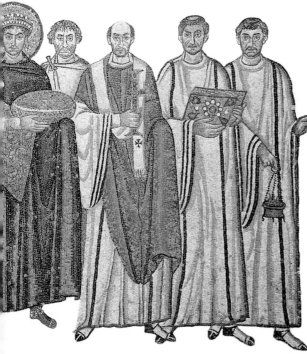

Left: detail from an 8th-century Coptic textile with a *crux ansata* motif and symbols of Jesus, including the *chi rho* (superimposed initials X P that form the monogram of Christ in Greek). Below: detail of a splendid 6th-century mosaic from the Church of San Vitale in Ravenna, Italy. The Roman emperor Justinian stands at center; he has a saint's halo, carries a gold paten, and is flanked by members of his court. In 533 Justinian issued an edict ordering the administrative reorganization of Egypt, placing control of each region in the hands of a *dux,* a combined civil and military governor, and a deputy, the *praeses,* supported by armed police, tax collectors, city and rural guards, and a substantial prison system. These secular authorities were intended to offset the power of the bishops. By this means Justinian was able to suppress the Monophysites and favor the Chalcedonians. However, his wife, Empress Theodora, favored the heretics. On her initiative, Monophysite missionaries were sent to Nubia between 545 and 580. There, together with Chalcedonians, they converted three kingdoms, Nobadia, Makuria, and Alwa, to Christianity. These new converts adopted Egyptian writing and customs and remained Christian until the 15th century.

rooted in the ancient Egyptian language of the pharaohs. It had evolved over time and was written in an adapted Greek alphabet, rather than hieroglyphics. The oldest form of Coptic is called Sahidic, and is the classical or standard dialect. (Other dialects are Bohairic, Fayyumic, Akhmimic, and Sub-Akhmimic.) The first works were translations of the Old Testament and later the New, based on Greek texts. Early on, collections of apophthegms and apocrypha of the Old and New Testaments were also translated into Coptic, and no doubt the lives of martyrs as well.

Perhaps Saint Anthony wrote letters in Coptic, but the first known original works in this language are those of the Desert Father Pachomius (founder of cenobitic monasticism) and his disciples, Theodore and Horsiesi. Then, at the beginning of the 5th century, Shenute (c. 334?–c. 451?), abbot of Atripe, now called Deir el-Abiad (the White Monastery) near Sohag in Egypt, brought Coptic to a literary level worthy of other languages of the Christian East. His writings include numerous homilies, catecheses (religious instructions) concerning monastic debates, advice to the officials of his time, and lively theological polemics against other Christian sects, including the Nestorians, the Gnostics, and the Origenics. Shenute's successor, Besa (d. c. 474), wrote his biography as well as many letters and catecheses.

Coptic translations of the Greek Church Fathers proliferated, including works by Basil of Caesarea, Gregory of Nazianzus, Gregory of Nyssa, Cyril of Jerusalem, and, notably, the Alexandrians Athanasius and Theophilus. The canons of the councils and deeds of Eastern martyrs were also popular. After the Chalcedonian schism, the history of the church was rewritten to present the anti-Chalcedonian views of the patriarchs Dioscorus and Timothy Aelurus. Once again, Byzantine oppression and internal divisions arose to dampen this flourishing enthusiasm for texts. But the

"Tired of struggling with my body, fearing to lose my life suddenly and unexpectedly, sound of reason and mind…I make this testament…I want my body to be buried in a shroud and that holy offerings and a funeral repast be celebrated for the repose of my soul." This is the late 5th-century testament of the Greek epic poet Aurelius Colluthus of Lycopolis. Although some literature was written in Coptic in this period in Egypt, Greek was often used for legal documents.

At the end of the 19th century, at the White Monastery in Upper Egypt, a library was discovered containing over 10,000 parchment fragments, including treasures of Sahidic literature and 8th-century versions of texts by the 5th-century monk Shenute. According to legend, he lived for more than 110 years. He fought paganism and defended Upper Egypt against invasions by a Beduin people known as the Blemmyes. He remains the most famous ancient Coptic author, although his work has not been studied fully. Left: in this fragment from *The Angel of the Waters,* Shenute writes of the tense wait for the annual summer flooding of the Nile. Below: a typical leather-and-wood case for reed pens belonging to a scribe named Pamio, from the Byzantine era (c. 500–700). It is decorated with an incised image of Saint Philotheus, armed with sword and shield, trampling a demon underfoot.

patriarchate of Damian again restored peace and unity to the Egyptian church, and revived the Egyptian production of homiletic literature and hagiographies (studies of saints' lives). Coptic creativity blossomed in the early 7th century; many leaders, including Rufus of Shotep, Constantine of Asyut, Pisentius of Qeft, John of Parallos, and John of Shmun promoted the arts, which rose to a new level of beauty.

The sculptural arts

Early Coptic architecture was first revealed when the late 3d-century necropolises called the catacombs of Karmuz were discovered in Alexandria. Other

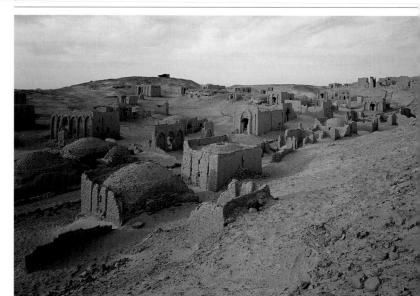

early buildings include a necropolis at Bagawat, dating to the 4th–7th centuries, the Shrine of Saint Menas, south of Alexandria, churches in Old Cairo, the cathedral at Ashmunein (ancient Hermopolis), and monasteries at Bawit, Saqqara, Esna, Wadi Natrun, Kellia, and near the Red Sea.

Churches were often built on a basilican plan: an oblong building with a sanctuary oriented to the east, terminating in a central apse, flanked by two smaller apses, intended for secondary liturgical functions. The basilica usually had a central nave with two aisles—a form that follows the arrangement of pharaonic hypostyle temples—and sometimes also a narthex (portico) and atrium. In Upper Egypt, the aisles were sometimes joined to a sort of tripartite ambulatory. This detail is not found anywhere else, and is typical of Coptic architecture, which otherwise conforms to the Mediterranean tradition. Another characteristic carried over from pharaonic architecture is the compact shape of the buildings, whose exterior walls sometimes sloped like the pylons of the ancient temples.

Bagawat, near the Kharga Oasis, is a necropolis comprising 263 funerary chapels built of unbaked brick. Each has one or two rooms, often covered by a dome. Some are decorated with pilasters or arches and frescoes with biblical scenes. Within are funerary pits for group burials. One section of the necropolis is occupied by pagan tombs similar in style to the Christian ones, except for the sarcophagi they hold, which are decorated with depictions of the gods Osiris and Anubis.

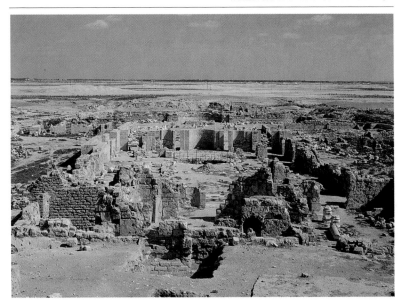

Inseparable from architecture, Coptic sculpture had a particularly decorative function. Autonomous sculpture in the round was rare. More commonly, sculpture was used to emphasize architectural elements: capitals, architraves, lintels, columns. Many niches accented the

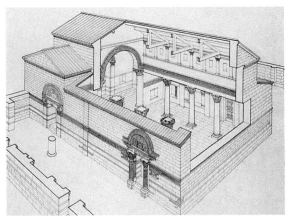

Above: the ruins of the great Basilica of Saint Menas near Lake Mareotis, which dates to the last quarter of the 5th century and is the largest known Coptic site in Egypt. Its floor plan measures 63 by 28 yards (57.6 by 25.6 meters). The vast transept, an unusual feature, creates an enclosure for the shrine it once housed. The 6th-century south church at the Monastery of Saint Apollo at Bawit has no transept. There, the sanctuary is not an apse but runs the full width of the central nave and is separated from it by a simple wall, which is pierced by an arch flanked by two columns. Left: a reconstruction of the latter church.

facades, whose walls were also set off with friezes.
Limestone and sandstone were used extensively. The
repertory of decorative motifs falls into two general
categories: extremely stylized geometrical or floral
elements (vines, acanthus leaves) and figurative
themes from the Bible (such as Daniel in the lion's
den), Christian history (episodes from the lives of
Christ and the Virgin or depictions of saints), or
myths (the birth of Aphrodite, the nymph Daphne
transformed into a laurel tree, Dionysos, the god of
the Nile, the cycles of Hercules and Orpheus, and
others).

Funerary stelae often depict the deceased within
an architectural enclosure, arms raised in prayer.
Certain stylistic characteristics are striking: the
figures generally possess wide eyes set in the middle of
the face, which is dramatically disproportionate to the
rest of the body. The break with classicism is obvious,
although some works do appear to refer to the classical
canon. Another curious trait is that the head is often
presented frontally, while the body is in profile. This
figural composition is the opposite of that employed in
ancient Egyptian art.

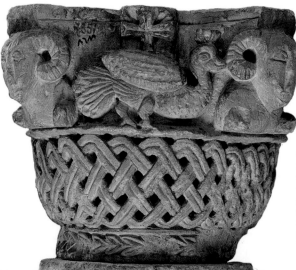

Below left: This 6th-
century column
capital takes the shape
of a woven basket sur-
mounted by a peacock-
and-ram motif. In the
Byzantine era the peacock
was a Christian symbol of
resurrection, probably
because it loses its mag-
nificent feathers in the
winter and grows them
anew in the spring; the
bird's flesh was also
believed to be incor-
ruptible. The ram
evokes the story of
Abraham, who was
ordered by God to
sacrifice his son,
Isaac, as a test of faith.
Abraham's compliance
won the mercy of God,
who accepted a ram in
Isaac's place. The ram
was also an emblem of
the suffering of Christ,
and was the animal most
sacred to Amun, one
of the chief gods of
ancient Egypt.

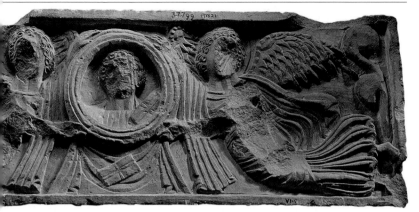

Aside from sculpture, ancient Coptic artisans produced an interesting assortment of domestic and funerary objects in wood and metal. The chronology of artworks remains insufficiently established and very controversial, and it is difficult to distinguish differences among various workshops and schools.

Painting

The earliest examples of Christian painting in Egypt are funerary images. Akin to the art found in the early Christian catacombs in Italy, these seminal works are marked by subtlety of line, natural grace in the figures, and a range of poses (as in the catacombs of Karmuz, late 3d century). Beginning in the 4th century, Egyptian Christian painting departs from the Roman tradition. Paintings in the funerary chapels of Bagawat in the Kharga Oasis adopt either a much more stylized and suggestive manner or a sumptuous, hieratic style, related to nascent Byzantine art. This imperial, hieratic style is also found in

Above: a decorative lintel from the 6th or 7th century. Christ in a mandorla supported by two angels was a common theme in early Coptic painting and sculpture. Narrative biblical scenes were also popular. Left: this small figwood fragment depicts a seated Virgin Mary spinning purple thread into a veil. Only a foot of the Angel Gabriel remains. Originally polychrome, it must have once been attached to a piece of furniture, perhaps a choir screen.

funerary paintings at Antinoopolis dating from the 5th–6th centuries. The rock church at Deir Abu Hennis, not far from Antinoopolis, shows traces of continuous 6th-century friezes representing episodes from the Gospels. The influence of the Greco-Roman pictorial tradition is still apparent here.

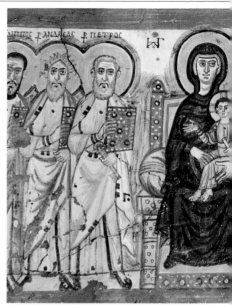

During the 1st century, a burial tradition developed in Egypt in which the face of the deceased was covered with a wooden panel bearing his or her portrait. These magnificent portraits (often known as the Fayum portraits, because many were found in that district) were produced until the middle of the 3d century. Some of them seem to depict Christians. The painting medium was distemper or encaustic (pigmented wax). This was also used in Coptic religious icons; the style of the Fayum portraits undoubtedly influenced the subsequent Byzantine icon tradition. Rare icons of Christ, Saint Menas, Saint Mark, Saint Theodore, and Bishop Abraham of Nisibis, made before the 7th century attest to this. We recognize in them the heritage of the Fayum portraits, translated into the characteristic Coptic style, which favors frontal figures, dilated eyes, a linear treatment of the face, and little respect for natural proportions.

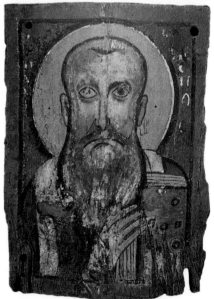

Coptic textiles

With their brilliant, warm colors, antique Coptic textiles have

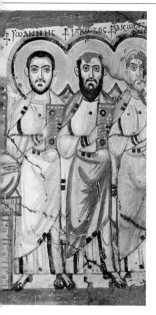

acquired a well-deserved reputation. They were principally made of wool and used dyes made from such organic pigments as madder, archil, indigo, and saffron. The oldest (2d–4th centuries) imitated Greco-Roman mosaics, using gradations of color. After the 6th century, however, the stylization in weavings became more and more extreme. In one technique details were drawn within large fields of color using a thread of unbleached linen. Woven themes were to a great extent related to those of sculpture and included mythological scenes, reinterpreted in Christian terms; Nilotic or hunting scenes; and, from the 4th century on, scenes drawn from the Old and New Testaments.

Left: a typical mixture of individualism and hieratic stereotype is seen in a marvelous painting from an oratory niche from chapel 6 of the Monastery of Saint Apollo at Bawit. Here we see the Virgin enthroned with the Child, who holds a scroll bearing the New Dispensation. They are surrounded by the Apostles, holding magnificent, gem-studded manuscripts of the Gospels. From left to right we see: Philip, Andrew, Peter (holding his symbol, a key), John (seated in the principal place at Mary's right hand), and the two Jameses. Below, far left: this portrait of Abraham, bishop of Hermonthis (d. 620) and superior of the Monastery of Saint Phoibammon, near Luxor, is one of the most ancient extant examples of Coptic painting. It was painted in distemper on a panel of acacia wood. Despite the conventionalized character of the large eyes and severe, closed mouth, there is no doubt that the artist wished to record the actual features of the holy man. The work was done after his death, to judge by the presence of the halo. Near left: these two miniature tondo icons represent the Virgin and the Archangel Michael, who play a large role in Coptic funerary ceremonies.

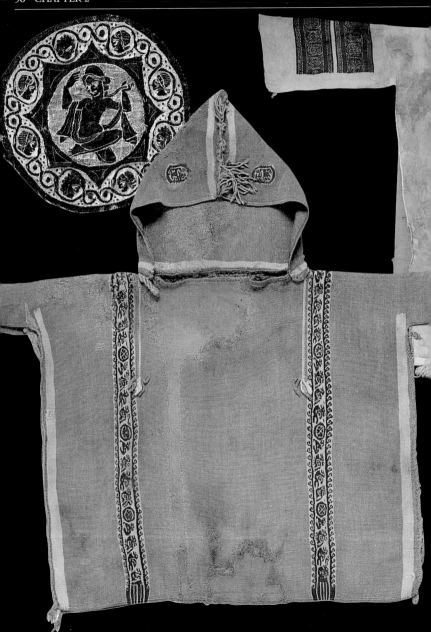

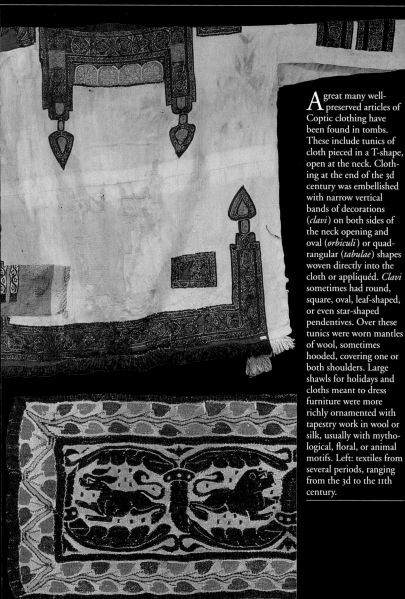

A great many well-preserved articles of Coptic clothing have been found in tombs. These include tunics of cloth pieced in a T-shape, open at the neck. Clothing at the end of the 3d century was embellished with narrow vertical bands of decorations (*clavi*) on both sides of the neck opening and oval (*orbiculi*) or quadrangular (*tabulae*) shapes woven directly into the cloth or appliquéd. *Clavi* sometimes had round, square, oval, leaf-shaped, or even star-shaped pendentives. Over these tunics were worn mantles of wool, sometimes hooded, covering one or both shoulders. Large shawls for holidays and cloths meant to dress furniture were more richly ornamented with tapestry work in wool or silk, usually with mythological, floral, or animal motifs. Left: textiles from several periods, ranging from the 3d to the 11th century.

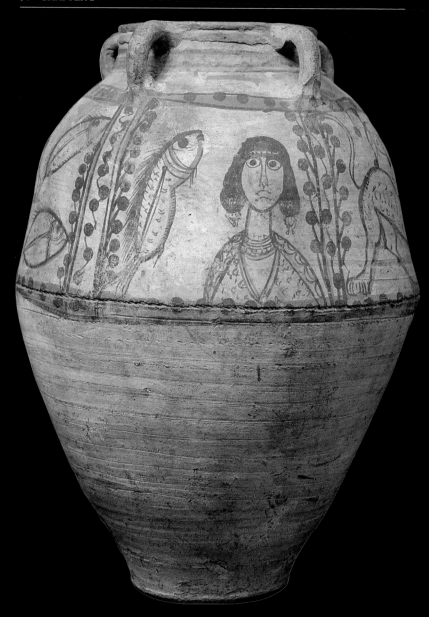

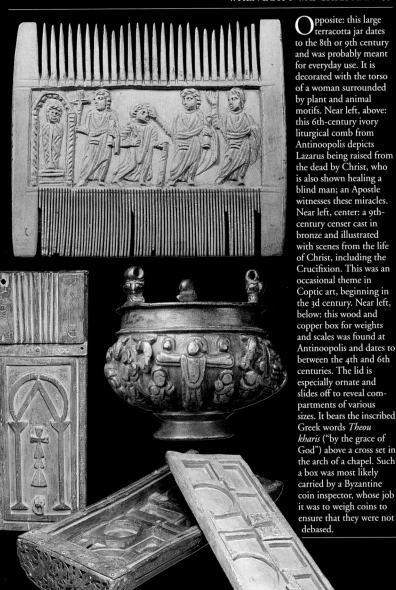

Opposite: this large terracotta jar dates to the 8th or 9th century and was probably meant for everyday use. It is decorated with the torso of a woman surrounded by plant and animal motifs. Near left, above: this 6th-century ivory liturgical comb from Antinoopolis depicts Lazarus being raised from the dead by Christ, who is also shown healing a blind man; an Apostle witnesses these miracles. Near left, center: a 9th-century censer cast in bronze and illustrated with scenes from the life of Christ, including the Crucifixion. This was an occasional theme in Coptic art, beginning in the 3d century. Near left, below: this wood and copper box for weights and scales was found at Antinoopolis and dates to between the 4th and 6th centuries. The lid is especially ornate and slides off to reveal compartments of various sizes. It bears the inscribed Greek words *Theou kharis* ("by the grace of God") above a cross set in the arch of a chapel. Such a box was most likely carried by a Byzantine coin inspector, whose job it was to weigh coins to ensure that they were not debased.

ⲑⲉⲟⲇⲟⲕⲓⲁ ⲛⲧⲉ
ⲉ̄ⲃⲟⲧ̄ ⲁ̄ⲑⲟⲥ

Ⲡⲓⲣⲁⲧⲟ̄ⲥ

ⲉⲧⲉⲙⲙⲱⲟⲩ ⲛ
ⲛⲓⲁⲅⲅⲉⲗⲟⲥ ⲉ̄ⲃⲟⲗ
ⲛⲓⲡⲧⲁϣ ⲉ
ⲉⲣⲉⲡⲓⲱ̄ⲣⲱ
ⲙⲟⲥⲓⲃ̄ⲧⲉϥ
ⲟⲩⲇⲉ ⲙ̄ⲡⲟⲩ
ⲣⲱ̄ⲭ̄ⲓⲁⲭⲉ
ⲥⲛⲉϥⲭ̄ⲁ̄ⲑⲟⲥ
ⲑⲟⲓⲥ̄ⲓⲁ̄ⲡⲟ

ثولية يوم الخميس
بلحن فاطس .

بى واطس

أدامنهائس ٠
ناو اروف دول
هى اشاف .
ارا اباكروم ٠
موه ان خادف .
اودا امبو .
روكه ان جا
ناف الكلاطوئه
افاوى نييوس

In 641 Muslims conquered Egypt and made it a province of an Islamic empire whose capital was Damascus (later Baghdad). It was governed by semiautonomous governors, sometimes under foreign dynasties. The Copts saw this as a liberation from the oppressive rule of the Byzantine emperors. Early relations between Christians and Muslims were mostly peaceful. Egypt slowly absorbed Arabic and Islamic culture and its Christians participated fully in the great flowering of Arab Muslim civilization that followed, even discarding the language of their ancestors.

CHAPTER 3
UNDER THE SIGN OF THE CRESCENT

Left: the dialogue between Christian and Muslim cultures in medieval Egypt is illustrated by this 13th-century hymnal, in which Coptic and Arabic texts appear side by side. Right: this fragment of medieval glazed ceramic depicting the head of Christ was unearthed in Fustat, the first Arab settlement in Cairo, founded in 642.

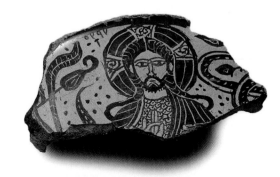

With a mere few thousand cavalry soldiers the Arab general Amr ibn al-As invaded an Egypt weakened by almost two centuries of persecutions and exploitation by successive Byzantine and Persian despots. With the exception of Alexandria, the country put up little resistance. "There shall be no compulsion in religion," proclaimed the Quran (Sura 2:256). For the Copts, who had suffered under coercive rule since 451, the Muslims were certainly no more to be feared than had been the Christian overlords they drove away.

According to Muslim tradition, the Prophet Muhammad (c. 570–632) had a Coptic concubine, Marya, and she bore him a son who died in youth. Muhammad cherished her; upon her death he was said to have commanded that the Egyptians be respected and pro-tected. Amr was benevolent toward the Copts from the

"The God of retribution, seeing the wickedness of the Greeks who cruelly pillaged our churches and monasteries everywhere they dominated, condemning us pitilessly, brought the sons of Ismail to the region of the south to deliver us. It was more than a slight advantage for us to be freed from the cruelty of the Romans." With these words, the 12th-century Christian historian Michael the Syrian evokes the Muslim conquest and the downfall of the Byzantines. Below: a miniature from an Arabic manuscript.

beginning, allowing Patriarch Benjamin, who had been living in exile, to return and regain control of his church.

Like other Christians living on Islamic soil, the Copts under the Umayyad and Abbasid caliphs of the 7th through 9th centuries were guaranteed freedom of religion and civil autonomy, but were not equal citizens. They were obliged to pay the *gizya*, a poll tax charged to all free, adult, non-Muslim men; and the *kharâg*, a property tax. The Muslims paid only the *zakât*, legal alms. Monks, at least at first, were exempt from the *gizya*, but not from the *kharâg*. Religious vocations were not heavily taxed, and archaeological finds suggest that many monastic sites, such as Kellia and Esna, experienced a renaissance in the 7th century.

Islamic integration

This emerging world offered prestige; conversions from Christianity to Islam were due less to economic than to social pressures. According to the law of the Prophet, a Christian who wanted to marry a Muslim had to convert to Islam. The reverse was not the case, and the children of a mixed marriage were considered Muslim.

At what rate did Islam spread in Egypt under the Umayyads and Abbasids? There are gaps in the documentation and the question remains fiercely debated. Some scholars of Coptic history, basing their research on fiscal sources, estimate that more than half of the Coptic population converted to Islam in less than forty years, and that Copts represented little more than 20 percent of the total population by the year 800. Others claim that Islamization was much less rapid and that Muslims did not become a majority until the end of the 10th century. This can be measured to some extent by established records: in 985 the Arab geographer al-Maqdisi noted that in many Egyptian

The capital of the Umayyad caliphs was in distant Damascus. They ruled the province of Egypt from 661 to 750 through local governors. The taxation they imposed was not, on the whole, as heavy as that of the Byzantines had been. Over time, however, taxes increased, doubling five times between 705 and 868. Above: this papyrus, probably from the 8th century, records an order from the Egyptian viceroy regarding an increase in the *kharâg*, or property tax.

towns there were not enough Muslims to build a
mosque. At the end of the 11th century the number of
Christian bishoprics remained stable at between fifty
and sixty. The rapidity of shift in religion varied
markedly from region to region. In Upper Egypt
Christians remained the majority until the 12th century,
or even later; such was the case in the city of Qus.

The spread of the Arabic language also occurred in
stages. Coptic remained the common language of the
majority of the population in the 5th century. As late as
820 writers were still producing original theological and
exegetical works in it. These included works by the
Patriarchs Agathon (r. 662–80), John III (r. 681–89), and
Mark II (r. 799–819); the Bishops Menas of Pshati (or
Nikiu) and Zacharias of Shu; and the monk Isaac of
Qalamun. Until the early 14th century, many liturgical
hymns were composed, while ancient works were
translated into Bohairic, the language of the Delta area,
which supplanted Sahidic, the language of Upper Egypt.
Other authors continued to write in Greek, such as
(probably) John of Nikiu (d. after 640), whose 7th-
century history of
Egypt and the world
has survived only in a
later text, written in
Ethiopian.

A bove: the door of the
late 12th-century
Church of Saint Mark
in Cairo has a predomi-
nantly floral, nonfigurative
decoration, in the spirit of
Muslim art. Left: a stucco
mihrab in the Mosque of
Ibn Tulun in Cairo shows
the souce of the style. It
was donated by al-Afdal,
vizier of the Fatimid
caliph al-Mustansir, in the
11th century. The renown
of Coptic woodworkers
and cabinetmakers
reached as far as India,
where the term *qabati,*
meaning "Copts,"
designates highly talented
carpenters. Coptic
artisans worked on a
number of important
Muslim buildings in
Egypt, as well as the great
Umayyad mosques in
Damascus and the
sanctuaries of Mecca.

First tensions,
first revolts

Under the Umayyad
Dynasty (661–750)
relations between
Christians and
Muslims were at first
cordial. The Coptic
elite had long occu-
pied important
administrative and
economic positions
in the state bureau-
cracy, and continued
to do so. But grad-

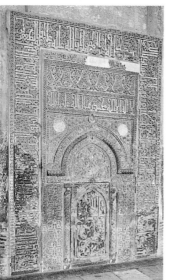

ually tensions began to form. In 706 an edict was issued prohibiting the use of Coptic in public documents. According to certain texts Caliph Yazid ordered the destruction of Christian icons in 722. Christian revolts shook the Nile Delta and the surrounding area around 770.

Resistance continued under the subsequent Abbasid Dynasty (750–870, in Egypt). In 829 Copts in the eastern Delta mounted a more serious revolt, rebelling against tax collectors. Caliph al-Mamun came from Iraq at the head of an army and bathed the insurgents in blood. Thousands of Copts were deported to Baghdad or sold as slaves.

In the 9th century the situation for Christians grew more difficult. As their numbers diminished, their vulnerability increased. More humiliating discriminatory measures were imposed on them: laws prohibiting Christians from holding processions, erecting a cross in public, or riding a horse. They were obliged to wear distinctive clothing, such as an identifying turban or belt. The exemption from the *gizya*, from which monks

Below: the Cairene Mosque of Ibn Tulun, built between 876 and 879, is largely the work of the Coptic architect Ibn Katib al-Firghani, although its minaret imitates one in Samarra, Iraq, and later renovations have greatly modified its original look. The story goes that the governor Ibn Tulun himself, twisting a piece of parchment distractedly between his fingers, gave the architect the idea for the spiral shape so characteristic of the exterior staircase of this minaret, which evokes ancient Mesopotamian ziggurats.

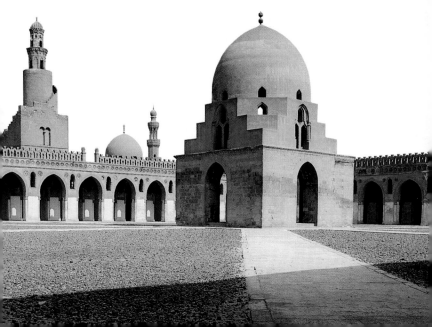

had benefited, was definitively abolished in 868. Relations improved for a time under two local dynasties that managed to free themselves from the authority of Baghdad: the Tulunids, from 870 to 905, and the Ikhshidids, from 934 to 960.

The Copts under the Fatimid Dynasty

In 969 the Fatimids, descendants of Fatima, daughter of the Prophet Muhammad, gained control of Egypt, and held it until 1169. Although the majority of the country's Muslims belonged to the Sunni (orthodox Muslim) sect, the Fatimids were Shiite, believing that Ali, the husband of Fatima, had been the first legitimate caliph after Muhammad. This is undoubtedly one reason the Fatimid princes were tolerant of the Coptic minority. Shia is, in fact, generally more liberal than Sunni Islam, and the sovereigns belonging to the Shiite minority had a natural tendency to lend support to other minority groups.

Nonetheless, the first century of Fatimid rule was marked by several tragedies. The Caliph al-Hakim

The Copts venerated many images representing saints on horseback. The iconography is borrowed from that of the Roman emperors, and reminds us that in the symbolism of late pharaonic Egypt the horse represented wealth. In the medieval epoch, however, Muslim legislation gradually forbade Christians to ride horses. The donkey was considered better suited to their status as *dhimmi* (persons protected by the state in accordance with the admonition of the Prophet Muhammad), implying a certain humility in their relations with Muslims. Below: a 7th- or 8th-century stela from the Fayum region.

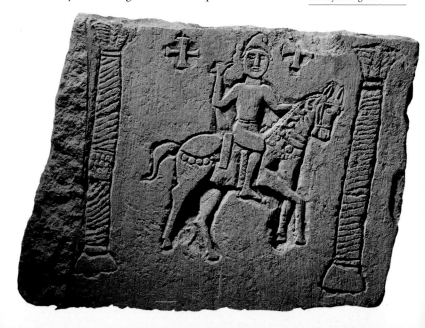

(r. 996–1021) was one of the most enigmatic princes of the Muslim Middle Ages, and was said by some to be mad. He imposed laws discriminating against Christians, Jews, and even some Sunni between 1003 and 1013. These were heavily coercive measures that restricted dress, pro-hibited public celebrations, and destroyed a number of monasteries and churches (among others, in 1009, the important Church of the Holy Sepulcher in Jerusalem). The goods of

non-Muslims were confiscated and they were excluded from holding government office. Some were forced to convert. A number of Copts renounced their faith, but they were able to return to it when the persecutions ceased at the end of al-Hakim's reign. The destruction had been terrible: many monasteries were left in ruin.

In 1055 came the next crisis: as a result of intrigues by hostile monks, Patriarch Christodulous was imprisoned by the Fatimid vizier al-Yazuri, who closed churches all across the country and burdened Christians with punitive taxes. Ten years later, tensions in Upper Egypt led to the massacre of sixty-six monks near Ashmunein. Much of this violence was due to the deterioration of relations between the Fatimids and the Christian Byzantine Empire, which was working toward a rap-prochement with the rival Abbasid Dynasty in Baghdad.

Adapting to the new realities of Muslim rule, Patriarch Cyril II (r. 1078–92) definitively transferred his seat from Alexandria to Cairo, home of the Fatimid government. Egypt had suffered great economic and political crises between 1066 and 1074, which almost cost Caliph al-Mustansir (r. 1036–94) the throne. By 1073, power had passed to a vizier of Armenian origin, a convert to Islam named Badr al-Jamali, who remained

Since the time of the pharaohs, the fishing communities of the Delta region had been known for their independent spirit. The great revolt of Copts from this area in 829–30 may be attributed as much to their tradi-tional irredentism as to religious causes. In forty-nine days the revolt was quelled by the caliph. "Thereafter," wrote the chronicler Maqrizi, "the Copts were obedient and their power definitively destroyed; none were in a position to revolt or even to resist the govern-ment, and the Muslims became the majority in the villages." Above: a fragment of 3d-century wool tapestry from Antinoopolis.

in office until al-Mustansir's death. He was succeeded by other converted Armenian ministers, who were often benevolent toward Christians, especially since the Armenian community in Egypt was very large.

For this reason, Copts fared better in the second century of the Fatimid caliphate. They recovered influential posts in the government, and the church experienced a period of prosperity. Nonetheless, the Christian population continued to shrink within an increasingly Islamic and Arabic country. The Coptic language itself was gradually restricted to use in the liturgy, and began to wane as a living tongue. The great patriarch Gabriel II (Ibn al-Turayk, r. 1132–45) consecrated the use of Bohairic (northern) Coptic in the liturgy. He also codified ecclesiastical law, with the help of the jurist Sadid ibn Yana. By the end of the 10th century Coptic authors began to write in Arabic and Christians increasingly Arabized their names. By the end of the 12th century, the liturgy itself began to be celebrated partly in Arabic.

Coptic art flourished under the Fatimids, their successors, the Ayyubids, and, later, the Mamluks. Christian architects were often invited to contribute to the construction of Muslim civil and religious buildings. Many churches were built after the Arab conquest, and the basilican plan was maintained, though on a reduced scale. Over time, an increasing emphasis in the liturgy on the celebration of the Eucharist led to a change in the design of churches. The sanctuary was separated sharply from the nave and placed within a chancel. This zone was reserved for the clergy and sometimes vaulted with a painted dome. In the Fatimid, Ayyubid, and Mamluk eras, the influence of Byzantine architecture

Left: on an 11th-century Islamic-era bowl a monk holds a censer and stands beside a cypress tree that is also a stylized *ankh* cross. By this date the cowled robe had already become the traditional dress of monks. The repressive politics and religious intolerance of al-Hakim bore especially heavily on the monasteries.

increased. Churches were elongated and the use of the domed vault became more widespread.

The period from the 7th to the 13th century represents the great era of Christian painting in Egypt. Many monasteries and churches today still preserve their sumptuous medieval frescoes. The repertory is extremely varied; the style blends Romano-Byzantine traditions with the distinctive iconographic genius of the Copts.

Manuscript illuminations, especially books of the Gospels, follow the same pictorial traditions found in the wall and ceiling paintings. Here the Byzantine

Left: the marble pulpit in the church of al-Muallaqa in Old Cairo. The name means "the hanging church," so called because it was built over an ancient Roman fortress. The pulpit dates from the patriarchate of Cyril II (r. 1078–92), when the church was the patriarchal seat. The pulpit's fifteen supporting columns represent Christ, the twelve Apostles (including a black one for Judas), and two Evangelists, Saint Mark and Saint Luke. Beneath the monument is buried Patriarch Abraham (r. 975–78), a contemporary of the first Fatimid caliph, al-Muizz (r. 969–75). Abraham was said to have proved the strength of the Christian faith to him by moving al-Muqattam, a hill that rises above Cairo, purely through fasting. This episode is recounted in Mawhub ibn Mansur ibn Mufarrig's monumental *History of the Patriarchs,* written between 1080 and 1088, using translations and biographies compiled by Severus ibn al-Muqaffa (d. c. 987). Al-Muqaffa was the first Christian author in Egypt to write in Arabic. He said, "Today Arabic is the language understood by the people of Egypt, whereas most of them do not know Coptic or Greek."

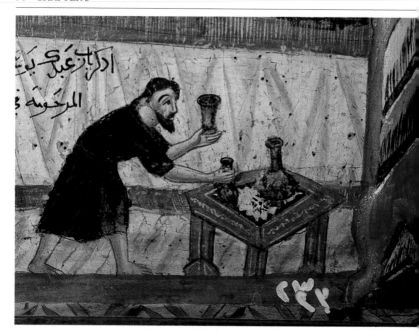

influence is very noticeable by the 12th century, when Gospels with historiated, narrative ornamentation were popular. Later manuscripts reveal the influence of Muslim taste in their geometric and floral motifs. The production of Coptic weavings continued uninterrupted throughout this period; Christians seem to have maintained a sort of monopoly on this industry under the Fatimids.

Coptic loyalty to the Muslims during the Crusades

In 1169 the last Fatimid caliph was ousted by his vizier, a man of Kurdish descent. He was the famous Saladin (Salah ad-Din, r. 1169–93), founder of the Ayyubid Dynasty, who took the title sultan. This was the period of the Crusades. Throughout the 12th and 13th centuries Franks (European Christians) invaded Palestine repeatedly, hoping to reconquer the lands sacred to Christianity for the West, and sometimes succeeding for brief periods. Egyptian Christians found themselves in an

According to Nasir Khusraw, a Persian chronicler who visited Egypt in the 11th century, weaving was a Coptic appanage. Even the *kiswa,* the veil used to cover the Qaaba in Mecca, was often made with *qubati,* a fine Coptic linen. Above: a medieval weaver and dyer at work, in a fresco from the Church of Saint Sergius in Old Cairo.

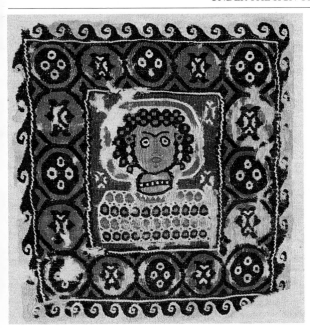

Textile production in medieval Egypt, especially in the Fatimid period, was controlled by the state institution of the *dâr al-tirâz*. Despite the Muslim context, many Coptic weavers maintained their traditions of figurative iconography. Left: this 9th-century linen and wool panel imitates Byzantine representations of richly clad women decked with jewels. Its highly stylized characterization and ornate decoration show a mixture of Christian and Muslim tastes. Below: a *tirâz* (a Persian word meaning "embroidery") is a band of cloth bearing an inscription with the name of the sovereign. It is a mark of authority or royal favor, and a guarantee of quality. This *tirâz* is of linen with the inscription, in flowing Qufic script, done in silk. The name is that of the Fatimid caliph al-Aziz (r. 975–96).

equivocal position: they were loyal to their homeland, but had ties of faith to the invaders. Suspected by the Ayyubid rulers of wishing the latter's victory, the Copts were once again expelled from the government. Saint Mark's Cathedral in Alexandria was razed, lest it be used as a fortress by any Crusaders who might land on the coast of Egypt.

After Saladin captured Jerusalem from the Franks in 1187, his politics softened and he allowed Copts to return to important public positions. The Copts then proved their fidelity to Egypt by fighting against the

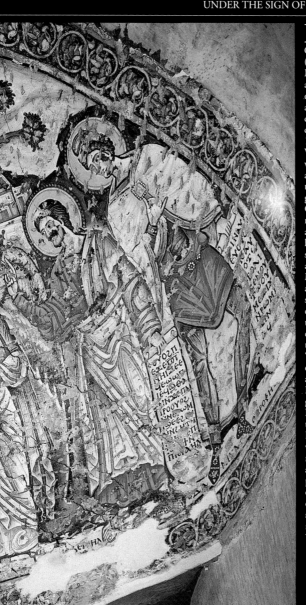

In May 1991, during restoration work in the Church of the Virgin (Sitt Mariam) at the Monastery of the Syrians at Wadi Natrun, an exceptionally fine early apse painting was discovered beneath a 13th-century mural. It depicts *The Annunciation.* The Virgin is seated, spinning wool that she draws from a bowl at her feet, while the Archangel Gabriel greets her, speaking Greek. (The text is written next to him.) His name is also written in Greek at his feet. Four prophets surround the Virgin; they are, from left to right: Moses, Isaiah, Ezekiel, and Daniel. Each holds a scroll in Coptic with an extract of his prophesy of the Incarnation. For example, Isaiah holds the text from Isa. 7:14: "Behold, a virgin shall conceive, and bear a son, and shall call his name Immanuel." In the background is the town of Nazareth. The style of the painting is quite Byzantine, and bears witness to the vitality of medieval Coptic pictorial art. Its date and interpretation are still much debated. The most likely date is c. 925, although some scholars place it as much as a century earlier.

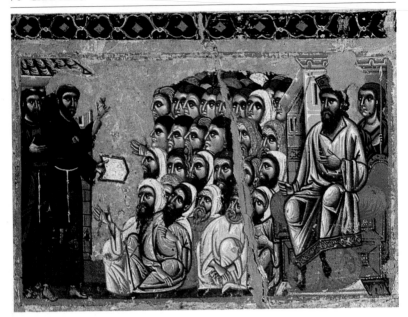

European invaders during the Fifth Crusade in 1218–22. Subsequent rulers tended to be tolerant as well. In 1219 al-Kamil (r. 1218–38) received Saint Francis of Assisi at his court; he was also friendly to the Holy Roman Emperor Frederick II. This was generally a peaceful time for the church, although its fortunes continued to fluctuate. In 1249 Crusaders under King Louis IX of France captured the Egyptian port city of Damietta; this loss, though temporary, set off an anti-Christian reaction throughout the country, but it fortunately did not last long.

The Coptic church was further disturbed by internal problems. Its patriarchal hierarchy was chronically unstable and corrupt and powerful individuals within it were able to interfere all too easily. Copts who converted to Islam could also be disruptive. From 1216 to 1235 and again from 1243 to 1250 the See of Alexandria was vacant. Between these two periods was the contested patriarchate of Cyril III (Ibn Laqlaq). Despite his great

Above: according to Saint Bonaventure, biographer of Saint Francis of Assisi, in 1219 Francis preached before Sultan al-Kamil, assuring him that "he had been sent beyond the seas…by the almighty God, to show him and his people the path to their salvation and to tell them of the Gospel, which is truth." A great many of al-Kamil's subjects were Christians, and he was thus familiar with Christianity. The dialogue between Muslims and Christians was of long standing in Egypt. Above: Saint Francis before the sultan, in an Italian painting done after 1254.

intellectual qualities, his rule, gained through corruption, provoked quarrels within the church that damaged the cohesion of the Coptic community. In 1235 there were only two bishops left in the whole Nile Valley.

The plight of the Copts under the Mamluks

Then, in 1250, a new Muslim dynasty seized power in Egypt. The Mamluks had originally been slaves of foreign descent who became the elite members of the Ayyubid sultan's army. They established a military regime that endured until 1517, and, like the Ayyubids, called themselves sultans of Egypt. The Mamluk period was notable for both its economic and cultural development and its political instability.

The fortunes of the Copts continued to worsen. Nonetheless, as a class they were educated and skilled administrators, and the country often required their services. Thus, the first Mamluk sultan, Aybak (r. 1250–57), named the Copt al-Faizi as his vizier. But as always, their position was precarious. When Christian influence became too apparent, they were exposed to the rancor of the Muslim masses and suffered several periods of persecutions. At this time, the reformist Muslim theologian Ibn Taymiyah (1263–1328) was very influential (and his thought remains an inspiration in Egyptian Islam today). He preached the strict submission of Christians to Islam and questioned their freedom to worship.

Sultan Baybars I (r. 1260–77) launched a military campaign against the last remnants of the Crusader states in Syria. To raise money for this, he levied heavy fines and taxes on Christians, accusing them of setting fires in Cairo and threatening to destroy their quarters of the capital if they did not pay. The sum was beyond the means of the community, but a monk named Bulus (Paul) al-Habis came forward to offer the money, although the source of his wealth remained mysterious. Under pressure from increasingly intolerant Muslim clerics, Baybars executed him, and his name was added to the list of

Below: Saladin. He became close to his Christian subjects after 1187. His private secretary was a Copt, Ibn Sharafi, who sponsored the important monastery of Deir-el-Sultan, attached to the Church of the Holy Sepulcher in Jerusalem. Saladin commissioned two Christian architects to construct the new defensive walls of Cairo, as well as the great fortified Citadel that overlooks the city from the hills of Muqattam.

medieval Christian martyrs in Egypt. In 1319 and 1320 there were other serious clashes in Cairo between Muslims and Copts, and eventually a fierce repression was imposed throughout the country. Few were the churches and monasteries that remained untouched. These dramatic events left an indelible mark on Coptic memory, and weakened the community for a long time to come.

The Coptic cultural renaissance of the 13th century

Despite these varying fortunes and many internal problems, Coptic culture had a remarkable cultural renaissance in the 13th century. Many important books were written in Arabic in the 1200s, including works of secular and ecclesiastical history, biblical commentary, and literature. Among the most notable were a great *Synaxarion,* or collection of lives of the Coptic saints, compiled largely by the bishops Peter and Michael Malig; *The Book of Histories* by Boutros ibn al-Rahib, a local and ecclesiastical history; al-Makin ibn al-Amid's *General History;* and the monumental *History of the Patriarchs* of Yusab, bishop of Fuwwah, completed with the assistance of other authors. Perhaps the best illustration of this literary flowering is the extraordinary activity of the three al-Assal brothers, members of a family of high functionaries in the Ayyubid government. They were bibliophiles and

Left: a 17th-century act of ordination of a deacon by an archbishop. Deacons are under priests in the hierarchy of the church. They have always held an important place in Coptic religious life, even in times when the ranks of the community have thinned. They are intermediaries with the congregation, modeled on the description in Acts 6:1–6. Yuhanna (John) ibn Sabba wrote: "The *shammâs,* also called deacon,…means server of the priest."

from *The Precious Pearl,* 14th century

These two pages from a medieval Coptic Gospel display the glory of the Abbasid style of illumination. The manuscript, written in Bohairic, dates to 1179–80 and has 77 paintings, mainly episodes in the life of Jesus and other scenes from the Gospels, inserted into the text in horizontal bands. Far left: the resurrection of the daughter of Jairus; near left: the Transfiguration.

Overleaf, left: a page from a Coptic manuscript, 1249–50. It bears six vignettes, presenting scenes from the Passion: the agony of Jesus in the Garden of Gethsemene, the kiss of Judas, the arrest of Christ, his appearance before Caiaphas, Peter's denial at cockcrow, and Christ before Pilate. Overleaf, right: the opening page of the Gospel of Matthew. At top is the baptism of Jesus in the River Jordan. The artist was influenced by Abbasid Mesopotamian art, as is seen in the style of clothing and bits of architecture, and the plasticity of the figures, done in rich polychrome on a background of gold.

art patrons, philosophers, theologians, lay preachers, and composers of hymns.

In 1238 Coptic law was systematized and interpreted in a *Nomocanon,* a collection of traditional laws and rules, compiled by al-Safi ibn al-Assal. This text became the principal reference for both civil and religious jurisprudence and is still used in Ethiopia today. Between 1240 and 1270 linguists began to revive the Coptic language: Yuhanna al-Samanudi wrote one of the first grammars and Abu Ishaq ibn al-Assal compiled a Coptic-Arabic dictionary.

Biblical studies also flourished, and the standard Coptic edition of the Holy Scriptures was progressively drafted at this time; known as the "Arabic Vulgate," it remains in use today. Collections and summaries of patristic commentaries abounded, as well as original works of analysis. We may cite in particular the texts of

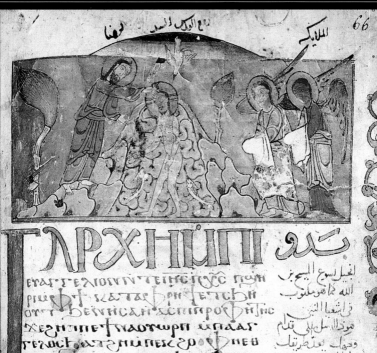

ΠΑΡΧΗΝΠΙ

ετΑϲΤεϪΟΙΝ ΝΤΕΠεϪϲ ΠϢΗ
ριε φϯ ΚΑΤΑ φρΗϯ ετϲϧΗ
Οντ ϩεΝΗϲΑΗ ΧεπιπροφΗπιϲ
Χεϩηππε ϯΝΑΟΥωρπ ΜΠΑΑϹ
ΓεϮΟϹΤ ΑΤεΜΠεΚϩΟ Νεβ
ΝΑϹΟΒϯ ΝΠεΚϢωΙΤ ϩΘΒϢΙ
ΠϩΡωΟ ΤΠεΤωϢ εΒΟλ ϩΝΠϢΑ
ϥεϪϪε ϲεΒϯε φϢΜ ΜΠΙϹ
ϲΟΤΤωΝ ΝΝεϥΜΑΝΜΟϢΙ
ΑϥϢωΠΙ ΝϪεΙωΑΝΝΗϹΠΙρεϥ
ϯωΜϲ ϩιπϢΑϥε ΟΥΟϩ εϥϩΙωΙϢ
ΝΟΥωΜϲ ΜΠΙΜεΤΑΝΟΙΑ ϧεΝΟΥΧω
εΒΟλ ΝΤεϩΑΝΝΟΒΙ ΟΥΟϩ ΝΑϤ
ΝΗΟΥ εΒΟλ ϩΑροϤ ΝΧεΝΑ
λεΑ ϯΙΡϹ ΝϯΧωρΑ ΠεΝΙΟρΔΑ
ΤΗΡΟϤ ΟΥΟϩ ΝΑΥϭΙωΜϲ ΝΤΟΤϤ
ϧεΝΠΙΙΟρΔΑΝΗϹΙΑρΟ εΤΟΥωΝϩ
ΝΝΟΥΝΟΒΙεΒΟλ
ΙωΑΝΝΗϹΔεΝΑϤϯϩΙωΤ ϤΝΟΥϧΒωϹΝΑΟΟϤ

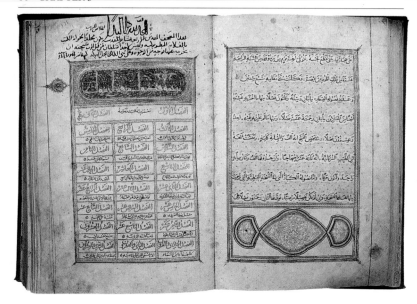

al-Safi, Mutaman ibn al-Assal, Ibn al-Rahib, Boutros al-Sadamanti, al-Wajih Yuhanna al-Qalyubi, and the great Katib al-Qaysar (d. c. 1267), who authored a remarkable commentary on the Apocalypse.

This revival of biblical studies led to the growth of a form of theology, rich in logic and philosophy, that had something in common with the Scholastic movement in the Western church. Bulus al-Bushi (c. 1170–1245), bishop of Old Cairo, wrote distinguished homilies; Abu-al-Khayr ibn al-Tayyib (late 12th–early 13th century) and al-Safi ibn al-Assal (c. 1205–65) wrote apologetic texts in response to debates and controversies that arose among Muslims, Jews, and the other Christian confessions. The great systematic collections of the divine and ecclesiastical sciences now made their appearance: *The Summa of Religious Principles* by Abu Ishaq ibn al-Assal and *The Book of the Demonstration* by Ibn al-Rahib; these set the stage for the encyclopedias of the early 14th century, such as Abul-Barakat ibn Kabar's 1320

In the 13th and 14th centuries, Coptic culture grew more and more Arabized. Above: a Gospel written in Arabic, dated 1340. Coptic became a dead language, although a handful of scholars tried to preserve it by compiling grammars and dictionaries. A *scala*, "ladder" (*sullam* in Arabic), is a lexicon of Coptic words written in columns, with their translations. Above right: in a *scala* by Bishop Yuhanna al-Samanudi (d. after 1257), we read the Coptic word *pre*, "the Sun" (the god Ra of the pharaohs), and its translation into Arabic, *ash-shams*.

Lamp of the Shadows and *The Precious Pearl* by Yuhanna ibn Sabba.

The sciences in Egypt were less affected by this revival of writing, perhaps because of the intensely religious character of Coptic culture. We may nevertheless mention the medical work of Ibn Bishr al-Katib (c. 1265) and works on astronomy by Ibn al-Rahib.

The 13th century was the golden age of Coptic literature in Arabic. When the Mongols conquered Baghdad in 1258, Cairo became the cultural capital of the Arab world. The relative tolerance of the Ayyubid sovereigns permitted Copts to contribute to this enriched intellectual life, as well as benefiting from it.

Below: the Copts played an important role in the diffusion of Arab Christian literature: 70 to 80 percent of the medieval Arab Christian manuscripts extant today are from scriptoria in Egypt, where medieval scribes used writing desks like this one from the 8th century.

When the Arab majority instituted long-lasting oppressive measures against the Copts in 1320, the Christian community in Egypt began a slow decline. It increasingly bore crushing taxes, levied to finance Mamluk military policy, and its cultural life faded. The church grew corrupt and sank into lethargy. The situation did not improve with the conquest of Egypt by the Ottoman Turks in the early 16th century—far from it.

CHAPTER 4
CROSSING THE DESERT

Under Turkish rule the Coptic community declined dramatically. French scholars accompanying Napoleon's expedition to Egypt from 1798 to 1801 estimated their number at no more than 160,000. Left: a period sketch of French soldiers being greeted by the monks of Wadi Natrun. Antiquarians were at first interested mainly in a few old monasteries and in ancient Coptic textiles. Right: Coptic tunics.

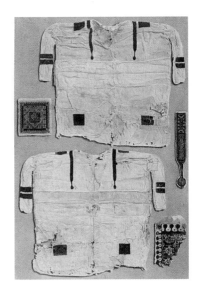

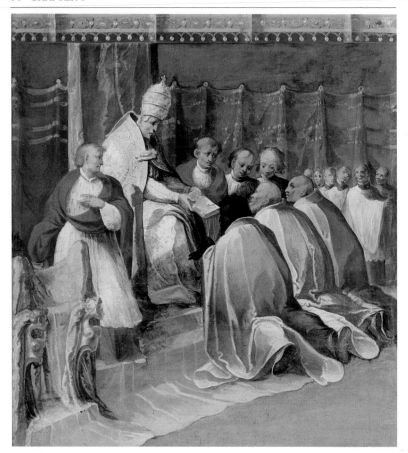

The expansion of the Ottoman Empire reached Egypt in 1517. The Ottoman Turks were Muslims. They administered Egypt, like their other provinces, under a pasha, or governor, who was appointed by the sultan in Istanbul. But despite its adept administrative system, Turkey did not retain control of Egypt; the Mamluks soon began to regain influence. By 1767 they had become the true rulers of the country once again. The process was not a tranquil one; Egypt was plunged for decades into a distressing state of near anarchy and its citizens suffered under the punishing fiscal policies of their overlords. Christians in

In August 1441, at the Council of Florence, Pope Eugene IV accepted the allegiance of the abbot of the Monastery of Saint Anthony, sent as emissary by the Coptic patriarch John XI. Above: the abbot kneels before the pope in a fresco by Cesare Nebbia (c. 1536–c. 1614).

particular were targeted. The decline of the Coptic community was so precipitous that by the end of the 18th century Copts represented less than 10 percent of the Egyptian population, which itself had fallen dramatically.

The Catholic temptation

It is hardly surprising that under such circumstances the Egyptian church sought support from the Roman Catholic church, a militant adversary of the Turks. Both Alexandria and Cairo were international trading cities, with a large population of European merchants and visitors. Coptic Christians had thus always been able to maintain contact with members of the Latin church, both Catholics and, later, Protestants. Over the centuries, the Western and Eastern churches had attempted several times to reunify, but without success. In 1439 an ecumenical council was convened in Florence to try once more. In 1441, the Coptic patriarch, John XI, sent a delegation to it. At one point a direct union of the church of Egypt with Rome was proposed, but in the end all such efforts proved ineffectual. Frequent negotiations in the course of the 16th and 17th centuries between the Roman papacy and the Coptic patriarchate failed to produce any agreement.

Returning from a voyage to the Levant, Guillaume Postel (1520–81) brought twelve Eastern alphabets to France. One was the first Coptic alphabet ever to be typeset and printed. Above: the title page of Postel's book. Below: a Coptic-Latin-Arabic lexicon in the form of vocabulary cards, c. 1760.

Throughout the period of Ottoman rule, Roman Catholic Christians continued to have a presence in Egypt. They had built Franciscan and Capuchin monasteries at holy sites and when the Coptic church fell into crisis, these outposts made some conversions. Thus a small community of Coptic Catholics came into being; in 1644 it was large enough to receive a papal administrator.

Rome's primary concern was to counter the influence of Protestant sects in the area, especially the Lutherans and the Moravian Brethren, who were also active in Egypt after the Reformation. A Coptic College was established in Rome in 1723, laying the

In 1636 Athanasius Kircher published his *Prodromus Coptus sive Aegyptiacus,* the first outline of Coptic grammar in the West. It presented a synoptic table of the thirty-two characters of the Coptic alphabet, describing the form (*forma*), the Coptic name (*nomen*), and Latin or phonetic equivalent (*potestas*) of each. Above left: a page from it.

foundations of a native Coptic Catholic hierarchy. In 1741 Bishop Athanasius of Jerusalem was named apostolic vicar, a direct representative of the Roman pope.

The West slowly rediscovers the Christians of Egypt

The 16th century was a great age of travel. Western visitors to Palestine and Egypt—pilgrims, diplomats, traders, or simple tourists—carried home reports and narratives that mentioned the "Cophtes," and brought Coptic manuscripts, lexicons, and grammars to Europe, many of them purchased in the monasteries of Wadi Natrun. In 1538 a French linguist named Guillaume Postel published the first printed Coptic alphabet. But an antiquarian and scientist named Nicolas-Claude Fabri de Peiresc was the first European, at the turn of the 17th century, to study the Coptic language seriously. It was he who perceived that it was heir to the mysterious lost language of the pharaohs. Tommaso Obicini (1585–1632), a Franciscan cleric and student of Arabic, and Athanasius Kircher (1602–80), a German Jesuit scholar and traveler, then made a systematic study of a collection of old Coptic-Arabic *scalae*—grammars and dictionaries—belonging to a Roman nobleman named Pietro della Valle. A Frenchman named Guillaume Bonjour completed a Coptic grammar in 1698. This work established the

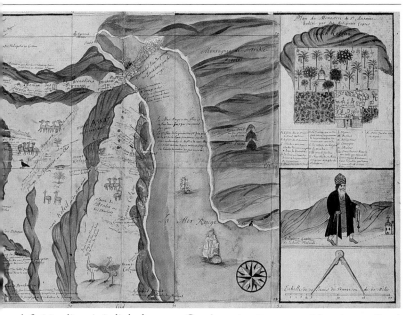

definitive linguistic links between Coptic and Egyptian hieroglyphics.

At Oxford University in 1675 a *History of the Copts* was published in Latin. This was the work of an Egyptian Christian, Yusuf Abu Daqan, who had taught Arabic in Europe some forty years earlier. Two years later, a German Dominican monk, Johan Michael Vansleb (1635–79), wrote a *History of the Church of Alexandria.*

In 1713 the Orientalist Eusebius Renaudot published a Latin translation of *The History of the Patriarchs of Alexandria* in Paris. As the taste for antiquities grew in 18th-century Europe, the search for manuscripts continued. Between 1707 and 1715 two Maronite Christians, Elias and Joseph Simon Assemani, brought an entire collection acquired at

A Copti.

Above: in 1717 a French missionary in Egypt, Claude Sicard, drew a "Map of the Deserts of the Lower Thebaid," featuring a Coptic monk. Near left: in 1743 the English traveler and chronicler Richard Pococke depicted a "Copti" accountant, wearing the blue-and-white turban required for Christians and holding an account book. Far left: the legend of a map drawn in 1700 by the geographer Nicholas de Fer has a pair of hermits: Saint Paul (with the raven that fed him) and Saint Anthony confronting temptation.

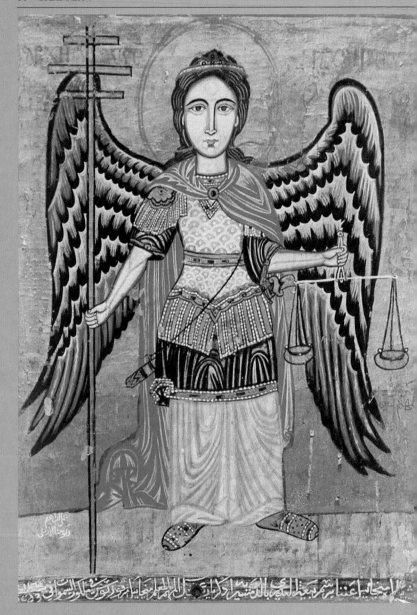

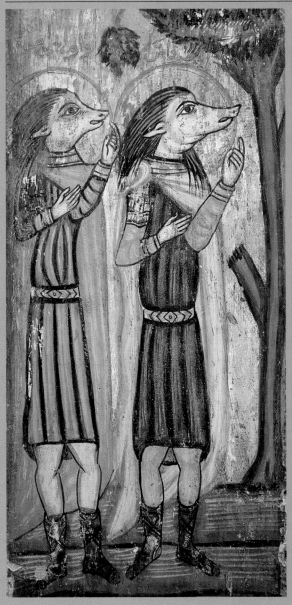

Literary activity among the Copts had almost disappeared when the West rediscovered them in the 18th century, but the icon-painting tradition was experiencing a creative revival. Little evidence of the art after the 7th century had survived, for old icons were sometimes burned in the fires needed for the preparation of myron, the holy oil used for sacraments and the benediction of sanctuaries and objects. From 1745 to 1783 the Armenian painter Yuhanna Karabid (Karapetian), the Coptic monk Ibrahim el-Nasikh, and their followers filled the churches of Old Cairo and other towns with hundreds of icons. These artfully blend Byzantine influence with specifically Coptic features: inscriptions are written in Arabic and dated according to the era of the martyrs. The choice of subjects also shows this mixed heritage. Far left: the Archangel Michael holds the scale of judgment for the weighing of souls, like the ancient Egyptian god Thoth. Near left: even more dramatic are these dog-headed saints; they are a sort of werewolf and were converted by Saint Mercurius, but call to mind the Egyptian god Anubis. To judge by the clothing style, the figures were most likely copied from a 4th- or 5th-century image.

Nom Hieroglyphique determiné	Transcription en lettres coptes	Mot Copte	Signification.
	Сⱳⲛⲧ (ⲡ.)	ⲠⲤⲬⲈⲚⲦ (ⲡⲛⲓ Ⲣⲟⲓ)	Pschent, (amda couronne des Pharaons)
	Ⲧⲱⲣ·Ⲧ·	Ⲧⲣⲉⲱ	La couronne Tesch (de couleur Rouge)
	Ⲟⲧⲩ·	La Coëffure Ôtf insigne divin
	Ⲧⲱⲩ·Ⲑⲱⲩ	(Ⲑⲱⲩ·Ⲧⲱⲩ)	Tosch, coëffure Royale, militaire.
	Ⲧⲟⲩⲧ	Ⲧⲟⲩⲱⲧ	Statue, Image, Simulacre.
	Ⲛⲡⲣⲉ	Ⲛⲁⲛⲡⲣⲉ	Graine, Grain Semence.
	Ⲕⲗⲥ·Ⲕⲣⲥ	Coffre, coffret
	Ⲛⲟⲩⲅ	Ⲛⲟⲩⲅ	Corde, Cordeau, Cable.
	Ϧⲙⲁ	Ⲙⲁϧⲓ (militance)	Lin.
	Ϭⲱⲩ	Ϭⲓⲙⲉ	femme
	Ϭⲏ·Ⲧ·	Ϭϧ·Ⲧ·	femme.
	Ϩⲣⲣ	Ϩⲣⲏⲣⲉ	Fleur.
	Ⲗⲓⲛⲁⲁ·Ⲗⲛⲥ·	Ⲗⲓⲁⲁⲛⲓ	Nourrice.
	Ⲃⲟ·Ⲃⲱ·	Ⲃⲱ·Ⲃⲟ·	Bois. (lignum)

As a youth in Paris, Jean-François Champollion (1790–1832) studied Coptic with the vicar of the local Coptic community. "I am devoting myself wholly to Coptic," he wrote in 1809. "I want to know Egyptian as well as I know French." In 1815 he edited a Coptic dictionary, which led him to the discovery that would catapult him to fame: deciphering the Rosetta Stone. Left: in his Egyptian grammar, words are written in hieroglyphs in the left column, transliterated into Coptic characters in the second, into Coptic words in the third, and rendered in French in the fourth.

the Monastery of the Syrians to the Vatican Library in Rome; in 1838–39 Henry Tattam gave another such to the British Museum in London.

Knowledge of the Coptic language now made rapid progress, thanks to the publication of dictionaries and grammars by Mathurin Veyssière de Lacroze in 1775, Christian Scholtz and Charles Godfrey Woide in 1778, and Raphael Tuki in 1778. In 1822 the archaeologist Jean-François Champollion finally broke the code of Egyptian hieroglyphics, using the Rosetta Stone, a tablet on which the same text was written thrice: in hieroglyphs, Greek, and Demotic (an early form of Coptic). To make his groundbreaking translation, he relied heavily on recent studies of the language.

The Copts, Napoleon, and Muhammad Ali

Napoleon Bonaparte's invasion of Egypt in 1798 had little direct effect on the destiny of the Copts, although

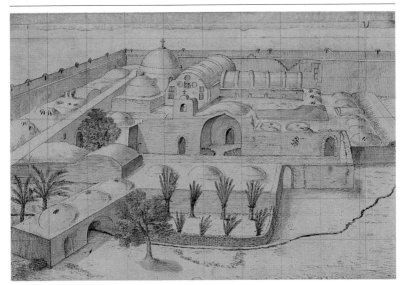

the French occupying army did create a short-lived auxiliary Coptic Legion. Patriarch Mark VIII (r. 1798–1809) advised his flock not to collaborate with the occupiers, aware of the danger that such intrigues represented. Napoleon was more concerned with winning over the Muslim elite than with the fate of local Christians. After his defeat by the British and their allies, Egypt fell once more under the nominal dominion of the Ottoman Empire and was again administered by the Mamluks, with gradually increasing intervention by the British. In 1811 Muhammad Ali, an officer in the Ottoman army, overthrew the Mamluks and for a time made Egypt almost independent of them and the Turks. He took the title khedive, or viceroy, and as ruler worked hard to bring Egypt into the modern age. He saw an advantage in aiding the Copts, who could help him to forge closer ties with the West, and he once more brought them into government circles. Over time, many Coptic families became members of the great landowning class of Egypt.

Above: the Monastery of Saint Pschoi, Wadi Natrun, c. 1800. Europeans visiting Egypt were intrigued by the Copts, but often disdainful. In 1799 the naturalist Charles-Nicolas-Sigisbert Sonnini de Manoncourt denounced the "perfidious character of these supposedly religious people, [whose] hatred of Europeans is deeper and more fierce than that of the Muhammadans." He added that, like the Muslims, the Copts cloister their wives and force them to wear veils. Left: a 19th-century illustration of Coptic ladies.

The history of the Copts in the modern era differs quite a bit from that of other Christian communities of the Near and Middle East, many of whom are attracted to Europe. The Copts, whose roots in Egypt are ancient, have always had a visceral attachment to their country and are deeply involved in every aspect of Egyptian life. The rediscovery of their rich history and heritage has furthered this sense of identity, and given birth to a new field of scholarship.

CHAPTER 5
THE COPTS IN THE MODERN ERA

Left: a Coptic family at their decorated front door. The Coptic community is experiencing an extraordinary spiritual and ethnic revival, inspired by the monasteries. Despite the difficulty of living within an Islamic culture that is sometimes prey to fundamentalism, the Copts have confidence in Egypt's long tradition of coexistence. Right: a Coptic monk.

In 1855 the khedive (ruler) Muhammad Saïd (r. 1854–63) abolished the *gizya* poll tax and allowed Copts to serve in the military. This was the first step toward granting them full Egyptian citizenship (which they achieved under Khedive Muhammad Tewfiq, r. 1879–92). Saïd's successor, the reformist Khedive Ismail, formed a new Consultative Council and by 1866 began accepting Copts into it. France and Great Britain, who were competing for colonial control of Egypt at this time, forced Ismail out of office. The next khedive, Tewfiq, was sponsored by the British. When he took the throne he proclaimed the equality of Christians and Muslims before the law. This principle was codified in law in 1913 and in the Egyptian Constitution of 1922. Since that time, there have always been Coptic members of the Egyptian legislative assembly.

Meanwhile, Cyril IV, patriarch from 1854 to 1866, was instrumental in developing a Coptic renewal movement. He carried out reforms of the liturgy, improved the educational system, founded new schools and printing presses, and developed ecumenical relationships with other Christian communities.

The archaeological discovery of the Coptic heritage

This revival coincided with the modern rediscovery of the Coptic heritage in Egypt. In the 20th century, the field of Egyptology blossomed, and great numbers of archaeological excavations were carried out. Although pharaonic Egypt garnered the greatest attention, scholars

The French Egyptologist Albert Gayet (1856–1916) came to Egypt in 1881. In 1889 he published a study of the Coptic collection in the museum of Bulaq, near Cairo. From 1896 to 1912 he excavated the ancient Roman city of Antinoopolis (founded c. 130), which had become a great Christian monastic center in the 5th century. He unearthed mummies, masks, portraits, fabrics, and other funerary articles. Above: Coptic objects from Antinoopolis displayed in Paris in 1896.

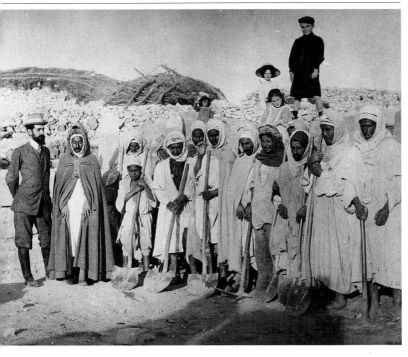

and the general public soon began to be interested in Coptic sites and the magnificent, ancient textiles found in them. Major museums began to acquire collections, which prompted the first systematic excavations of Christian buildings in the Nile Valley. The Austrians dug at Saqqara; the Englishman William Flinders Petrie at Fayum; Gaston Maspero at Akhmim (1881–86); and Albert Gayet at Antinoopolis (1896). Finds from the latter two were presented with not a little sensationalism at the Paris Exposition Universelle (world's fair) in 1900, and created a great stir. In 1902 Gayet published a book, *Coptic Art,* which argued that this art was an indigenous Egyptian expression of a "national" resistance to Greek culture. It was harshly criticized, but whatever its limitations, it indisputably played a revelatory role. Excavations of the great monastic sites at Bawit and Saqqara soon followed (led by Emile Chassinat and Jean

Gayet's discoveries at Antinoopolis were scattered among the museums that had financed his expedition. He was criticized for this dispersal, for his hasty digging methods, and for his romantic interpretations. He more or less claimed that he had discovered the mummies of Saint Serapion and the Alexandrian courtesan Thaïs, whose legendary quarrel with the priest Paphnutius had been popularized in an 1890 novel by Anatole France and an 1894 opera by Jules Massenet. Above: Gayet and his staff.

The Pachomian Monastery of Saint Apollo, founded at Bawit c. 385–90, was discovered by the archaeologist Jean Clédat (1871–1943) in 1900. It lies on the left bank of the Nile, not far from Ashmunein, and was originally surrounded by a wall about 2,300 feet (700 meters) long. The monastery reached its apogee in the 6th and 7th centuries, when it housed several thousand monks, and was abandoned in the 12th century. In the winter of 1902 Clédat uncovered two churches, one in the south of the site (partially reconstructed at the Musée du Louvre, Paris), the other on the north. Far left: two views of the north church. The two are quite distinct in style. The north church was built of sun-dried and fired bricks, with door frames, tympana, and columns in a poor white limestone. The building's west narthex, four-columned nave, and east-facing sanctuary were separated by woodwork; in the south church, these elements were divided by walls. The walls of both churches were covered with paintings and the columns were painted with figures of saints. The fallen column here shows Saint George in military dress. Near left: Clédat at Bawit, 1901.

Clédat in 1901, Jean Maspero in 1912, and James Edward Quibbel in 1905–10); and Hugh Evelyn-White conducted research at the monasteries of Wadi Natrun. At pharaonic-era sites more attention was now paid to vestiges left by the Copts who had occupied them for a time. In 1921 Bernard Bruyère began investigating Deir el-Medineh, where a Coptic monastery had once been housed in the ruins of a temple of Hathor.

Coptic philology, meanwhile, also progressed, mainly in Europe, rather than Egypt. The first truly scientific Coptic grammar, by Ludwig Stern, appeared in 1880, followed by Georg Steindorff's 1894 grammar of the Sahidic dialect and Father Alexis Mallon's 1904 grammar of Bohairic. In 1893 Emile Amélineau published an outline *Geography of Egypt in the Coptic Era*. At the turn of the century Carl Schmidt pioneered studies of Gnosticism, Manicheism, and other branches of early Christianity; he published German translations of Gnostic Coptic manuscripts in European libraries and, in 1930, first identified the Manichean manuscripts of Medinet Madi. In 1925 the Belgian Louis-Théophile Lefort began his study of the life and works of the Desert Father Saint Pachomius and his successors. Between 1929 and 1939 the presses of Oxford University produced the monumental *Coptic Dictionary* of Walter Ewing Crum, the labor of a life devoted to the study of Coptic texts.

Catholic, Protestant, Orthodox Copts

In 1876 a financial crisis connected with the building of the Suez Canal disrupted Egypt, and was resolved only with French and British aid. In 1882 Britain occupied the country. These were traumatic events, but they also helped to open Egypt to new ideas. Within the Christian

Right: the winged lion of Saint Mark appears on the coat of arms of the Coptic Catholic patriarch Mark II.

W. E. Crum's *Coptic Dictionary* comprised all the Coptic dialects known by about 1940. An indispensable tool for scholars, it was published in 1939 and revised in 1961 to include new words found in the Gnostic texts of Nag Hammadi. Left: title page of the dictionary.

community, Roman Catholic and Protestant Copts took greater advantage of this than did their Orthodox brethren. In 1895 they numbered some 20,000—enough for Pope Leo XIII to create a Coptic Catholic patriarchate. Unfortunately, its first patriarch, Cyril II, was dismissed in 1908 over questions of fiscal impropriety, and no successor was named until Marc II Khouzam in 1947. By then Coptic Catholics numbered about 60,000. Similarly, in 1878 the Coptic Protestant community gained legal recognition. The largest denomination was the United Presbyterian Church of Egypt, which in 1926 took the name Coptic

While both the Coptic Orthodox church and the Coptic Catholic church lay claim to the succession of Saint Mark, only the latter recognizes the authority of the pope at Rome. Ecumenical relations between the two churches remain problematic, and Orthodox Copts rebaptize Catholic Copts who have converted. Below: an 1865 painting depicts a festive baptismal procession, with the congregation intoning the hymn *Axios,* "he is worthy."

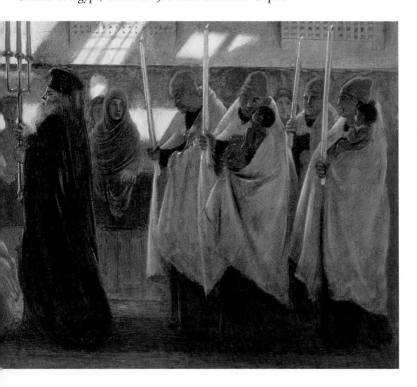

Evangelical Church. In 1949 it had 80,000 members, out of 160,000 Egyptian Protestants.

Meanwhile, lay members of the Orthodox church became more and more critical of the clergy's conservatism and its poor management of ecclesiastical possessions. In 1874 a *Maglis Milli,* or Congregational Council, was created, over the protests of Patriarch Cyril V. This created harsh internal tensions, which the govern-

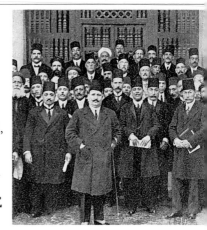

A BRIEF GUIDE
TO
THE COPTIC MUSEUM
AND TO THE
Principal Ancient Coptic Churches of Cairo
BY
MARCUS H. SIMAIKA PASHA, C.B.E., F.S.A.

ment attempted to appease, but with only mixed success. For more than half a century, the patriarchate's relations with the reform-oriented elite of the community were very stormy. Finally, in 1955 Patriarch Yusab II was accused of corruption, suffered an assassination attempt, and was formally deposed.

The Copts at the forefront of the struggle for Egyptian independence

Despite these disputes, the role of the Copts in the life of Egypt grew ever more important. The country had long fretted under the control of colonial Turkish and British powers. In 1882 the Egyptians mounted a nationalist revolt under the leadership of Ahmed Orabi (1841–1911). Patriarch Cyril V supported this movement. In the early 20th century the country even had a Coptic prime minister, Boutros Ghali (b. 1846), who was assassinated in 1910 by a Muslim ultranationalist. In

The dynasty that reigned in Egypt from 1805 to 1952 maintained good relations with the Copts. From 1805 to 1822 Master Ghali, a Coptic Catholic, was financial counselor to Muhammad Ali; he was executed for refusing to impose heavy taxes on the peasantry. Above: a 1920 visit by King Fuad I to the Coptic Museum of Old Cairo, built in 1908 by Marcus Simaika. Under Fuad the cabinet always included a few Coptic ministers, especially in finance, agriculture, and foreign affairs. This tradition has continued to this day: Boutros Boutros-Ghali, Secretary General of the United Nations from 1991 to 1997, was foreign minister under Anwar Sadat.

1914, as World War I began, the British imposed a protectorate on Egypt, with an heir of Muhammad Ali as titular ruler. In 1917 they installed Sultan (later King) Fuad I (r. 1917–36). In reaction, the Egyptians founded the broadly nationalist Wafd party, under the Muslim leader Saad Zaghlul (1858–1927); the Copts were at the center of the movement.

This commitment went hand in hand with bold demands on behalf of their own community. In 1911 an influential congress of Coptic intellectuals and notables met at Asyut, against the wishes of the church hierarchy, and called for more concrete rights and greater recognition for Christians. Under Fuad, the Copts became omnipresent on the political and social scene; it was not unusual at this time to see flags bearing an emblem of the Christian cross embraced by the Muslim crescent flying during large street demonstrations.

Starting in the 1930s, however, new movements such as the Muslim Brotherhood arose that increasingly associated nationalism with a militant Islamic revivalism. The atmosphere of national unanimity was soon lost. Corresponding to the Islamic revival of those years was a new awareness among the Copts of their

The renewal of Coptic monasticism has also affected women: six important convents, four of them in Cairo, today house some 500 nuns. Below: nuns pray under the guidance of their spiritual father. Since 1981 Patriarch Shenuda III, determined to grant women a larger role in the life of the church, has also ordained a number of deaconesses (*shammasât*), who provide social services (aid to the poor and infirm) and pastoral guidance. In numerous dioceses, there are also active cloistered nuns, such as the Daughters of Mary in Beni Suef, and "consecrated daughters" (*mukarrasât*).

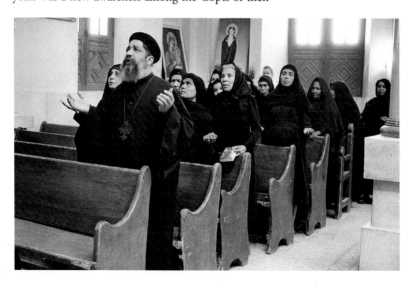

own identity and a renewed spiritual dynamism. For example, a deacon of the church, Habib Girgis, founded a group of Sunday schools in 1918 that established and taught a permanent catechism. This educational reform reached large numbers of Coptic Christians and helped them to rediscover their rich religious and cultural heritage. They were encouraged to work from within toward the reformation of a church that some considered to have grown decadent.

Revolution and after: dark years and renewal

Throughout World War II the Egyptian government continued under British control and remained unstable and weak. The reign of Faruk (r. 1936–52) was discredited by corruption and a humiliating military defeat in its 1948 war with the new state of Israel. The monarchy was toppled in 1952 by a new military leader, Colonel Gamal Abdel Nasser. He set Egypt on a course of modernization, reform, and socialization under which Christians in particular suffered. A good many prosperous Coptic families owned interests in businesses, banks, and public services; all the well-to-do were harshly affected by Nasser's nationalization of banking and industries. Large Christian landowners in Upper Egypt were subjected to agrarian reforms. All the political parties in which the Copts had a substantial role were suppressed.

Nasser was ardently secular. His vision was of a nonreligious Arab state. Religious foundations in general suffered confiscations and suppressions (including the Muslim Brotherhood), and the Copts—who were

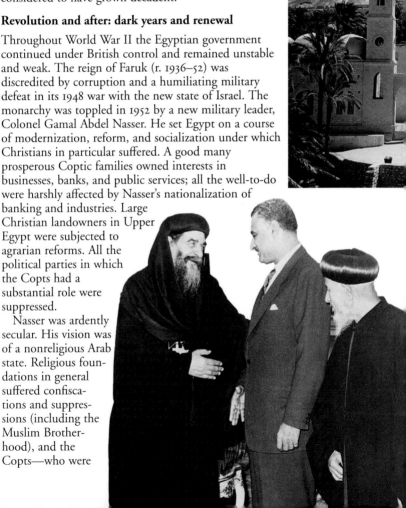

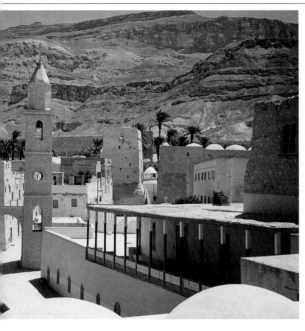

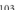

Far left: Patriarch Cyril VI meets with President Nasser in 1968. Relations were often strained between the patriarch and the president, whose complicated strategies with the Islamists and the Muslim Brotherhood led him—despite the fact that he broke with these groups by 1954—to expel the Copts almost entirely from public life. Nevertheless, Cyril's leadership was vital for the Coptic church. He was particularly active in improving relations with the Church of Ethiopia, which was granted full autonomy in 1959. A former monk and hermit of extraordinary charisma, he was committed to encouraging the renewal of monasticism. Near left: the venerable Monastery of Saint Anthony of the Desert, near the Red Sea, was nearly abandoned in the 1950s; by 1969 it had been restored and housed some 80 monks. Today, thirteen autonomous monasteries house several hundred monks, and numerous ancient monastic sites have been restored to active life. This renewal is of great value because bishops are chosen from among the monks.

Egyptians but not Arabs—were certainly not exempt. In 1955 the assets of the Coptic *waqfs*—religious real-estate foundations—were confiscated. All questions regarding the personal status of Christians were transferred from community courts to state courts. The *Maglis Milli* was disbanded and was not reestablished until 1972. Many wealthy Christians and Muslims left the country and emigrated to the United States, Australia, and Europe, laying the foundations of a diaspora that flourishes today.

In spite of these upheavals, however, the Nasser years were also a period of renewal for the Coptic church. This was due above all to the extraordinary reformist energy of Patriarch Cyril VI (r. 1959–71), whom Copts today consider a modern saint. Cyril had begun his career as a monk of the desert. He worked well with Nasser, and was able to preserve his church from secular interventions. Taking the reins of the Coptic community in hand, he was particularly determined to revive the monasteries, which had grown moribund. He enlisted

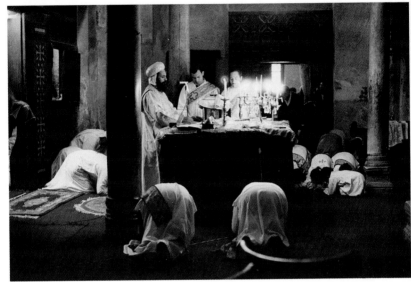

the help of young monks such as Matta el-Meskine, who belonged to the new generation educated at the famous Sunday schools and who hoped to rediscover the spirituality of the Desert Fathers. In just a few years Cyril VI succeeded in restoring the dozen surviving monasteries.

An Eastern spirituality for our times

The resurrection of Egyptian monasticism had conspicuous repercussions in the life of the Coptic people, for the monasteries have always maintained a constant dialogue with the lay community.

Today, the liturgy lies at the heart of Coptic life. Influenced by monastic customs, it is long (a service lasts at least three hours) and is followed closely by large and attentive congregations. Its communitarian, participatory character has done a great deal to strengthen the bonds of unity among the faithful. Copts are ceaselessly exhorted by their deacons to participate fully in the drama of the Eucharist and to express their faith forcefully. An abundance of readings (in Arabic, not Coptic) gives the Mass a pronounced catechistic

Above: deacons bow before the bread and wine as it is consecrated by a bishop; above right: the prayer to Our Father is recited with one's palms turned skyward. Patriarch Shenuda III has said: "The inner life and the liturgy are the whole foundation of life." Coptic religious practice has a strongly collective dimension. Some people see and decry a certain rejection of the modern world in this revivalism, yet the pure, radical, no-excuses faith of the Coptic people is itself a testimonial of our age. The prayer recited before Communion expresses Coptic veneration of the Eucharist: "I believe, I believe, I believe and confess to the last breath, that this is the

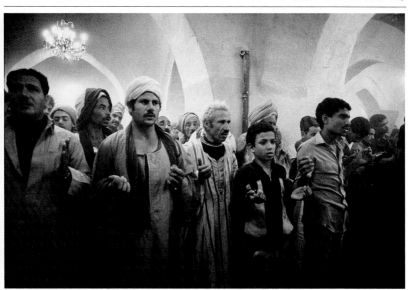

quality, and its rituals are powerfully resonant. Incense is used lavishly (the ancient Egyptians called it *sontjer*, "that which makes divine"); icons and relics of saints are worshiped with a naive, passionate fervor. Chants have distinctive, repetitive cadences, probably inherited from pharaonic hymn traditions, and are sometimes still sung by blind cantors to the sound of cymbals. The grandeur of the Christian mystery is constantly affirmed in texts that blend the Coptic, Arabic, and Greek languages. All this contributes to make Coptic worship a privileged, mystical experience. The worshiper has an intimacy with the sacred that Egyptians have always felt to be essential to life.

It is in the liturgy, especially that of the Eucharist, or consecration of the Host, that one most senses the presence of the ineffable. This sense is inseparable from the true faith in God that nourishes the soul of the Coptic believer. Indeed, it is not unusual for a worshiper to assert that he or she can see angels celebrating the sacrament with the priest in the sanctuary. Signs of God do not belong to the past; they abound in our own time: the miracles of Patriarch Cyril VI and of the monk

life-giving body that your only-begotten Son, our Lord, God, and Savior Jesus Christ took from our lady, the lady of us all, the holy *Theotokos* Saint Mary. He made it one with his divinity without mingling, without confusion and without alteration. He witnessed the good confession before Pontius Pilate. He gave it up for us upon the holy wood of the cross, of his own will, for us all. Truly I believe that his divinity parted not from his humanity for a single moment nor a twinkling of an eye. Given for us for salvation, remission of sins and eternal life to those who partake of him. I believe, I believe, I believe that this is so in truth. Amen."

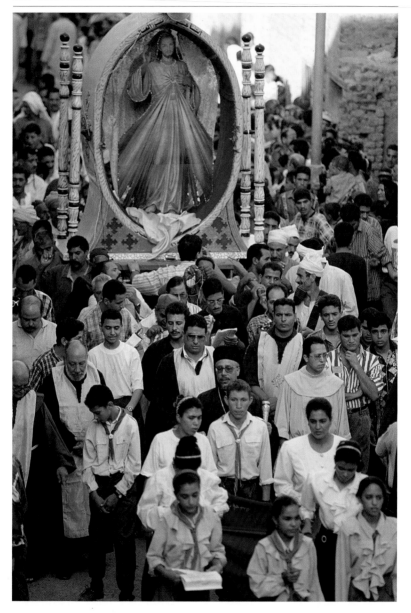

Yustus of the Monastery of Saint Anthony of the Desert (who died in 1976), the apparitions of the Virgin at a Coptic church at Zeitun in 1968 and at the Church of Saint Damian in Shubra, a suburb of Cairo, in 1976 are illustrations of this.

A calendar of religious holidays

For Copts, time itself is sanctified. Throughout the year, religious holidays follow one another in a sustained rhythm that recalls the days of the pharaohs: there are feast days of the Lord, the Mother of God, and all the saints and martyrs. Some are related to Middle Eastern or Egyptian sites; many have a great deal of local color. One such is the feast of

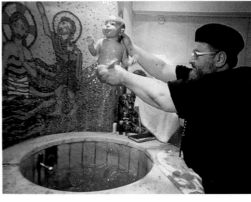

the Epiphany, or baptism of Christ, on January 19. In olden times this was a great celebration of the Nile River. Christ's Entry into Jerusalem is marked with a solemn ceremony on June 1; *Shamm en-nesim,* Easter Monday, is a local and national holiday, when Muslims and Christians willingly come together. Moreover, it is not unusual to see Muslims participating in the more important ceremonies of their Christian fellow citizens as a gesture of friendship.

Most festival days are preceded by periods of fasting or abstinence. There are a striking number of these, totaling roughly 250 days per year. The major ones are still closely observed by lay people, despite the intrusive rhythms of modern life. The fast for the Feast of the Assumption, which runs from August 7 to 22, is sometimes also followed by Muslim women who wish to honor the Virgin Mary. During fasting, no meat or other animal products are eaten and no food or drink is taken between sunrise and sunset.

The most intense periods of the religious year are

Left: a pilgrimage procession at Deir Dronqa, near Asyut. At more than sixty annual pilgrimages in Egypt crowds worship icons and relics, participate in liturgical ceremonies, offer lambs in sacrifice, and give alms to the poor. Some occasions last for days. At such festivals the ancient pharaonic custom of incubation is sometimes practiced: with the aid of exorcists one passes the night in a sanctuary in order to be cured of a disease or delivered from possession. In the baptistries the sacrament is administered to crowds of children. Above: a Coptic baptism involves a triple immersion in water, symbolizing a mystical burial followed by a resurrection in Christ.

those of the *muled*s, or pilgrimages to the tombs of martyrs and saints, and to the places visited by the Holy Family. Group baptisms, animal sacrifices, collective healings, solemn processions, dances, and joyful picnics turn these enormous gatherings into veritable sacred village fairs that shape the identity of the community. Many of these pilgrimages have origins in pharaonic antiquity; the Muslims observe similar ones, and attend them just as assiduously. For this is Egypt the Eternal, where, if one looks closely, the cross and the crescent together embrace the heritage of the most distant past.

Above: the well-known Coptic painter Isaac Fanous combines traditional subjects and a clean, modern line in his icons.

Is Islamic-Christian coexistence endangered?

When Anwar Sadat became president of Egypt in 1970, following the death of Nasser, he quickly rejected his predecessor's socialism. He developed closer ties to the West and a program of economic liberalization, called *infitâh*. The overall economic situation in the country improved, and with it that of the Copts. After years of continued strife with the Jewish state of Israel, Egypt spearheaded a historic peace accord in 1978. In bringing this about, President Sadat received support from his foreign minister, Boutros Boutros-Ghali, a Copt who played a key role in the successful negotiations at Camp David in the United States.

But Sadat's tolerant policies were unpopular with Islamic fundamentalists, and stoked the fires of religious reaction. The fundamentalists demanded that Egypt adopt *sharia,* traditional Quranic law, which grants Christians only second-class citizenship. Sadat's own attitude was not without some ambiguity. The violent clashes that erupted between Christians and Muslims in May and June of 1981 led him to punish both the Islamists and the Coptic community. The patriarch of the time, Shenuda III, had been resolute in his defense of the Copts, and was officially deposed. Shortly thereafter, on October 6, 1981, Sadat was assassinated by militant Islamic fundamentalists.

His successor, Hosni Mubarak, has worked hard to pacify relations between the majority Muslims and the religious minorities of Egypt. Restored to the patriarchate in January 1985, Shenuda III has also made a conscious effort to intervene less visibly in political matters. But Egypt's considerable economic problems have furthered the cause of the fundamentalists, although they remain a minority. They regularly present the Copts as scapegoats for all the country's ills. Government authorities prefer not to stress the gravity of these tensions between two devout communities. The church, too, praises national unity and is anxious to prove its unflinching loyalty to the state. Meanwhile, the Coptic diaspora has grown in the

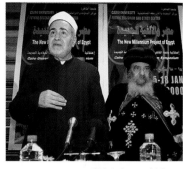

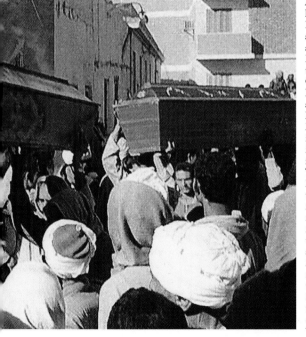

Christians and Muslims in Egypt maintain an ongoing dialogue of great intensity. Above: in January 2000 Patriarch Shenuda III and Grand Sheikh Muhammad Sayed Tantawi, Imam of al-Azhar University and the highest authority in Sunni Islam, together denounced a riot between Christians and Muslims in Upper Egypt in which twenty-two people were killed. On March 13, 1997, Muslim extremists carried out a terrorist attack that killed fourteen people, Muslim as well as Copt, in the village of Bahgoura, in Upper Egypt. Left: the funeral of the victims. The dire poverty of most Egyptians helps to explain the success of the fundamentalists, who are estimated to constitute no more than 10 percent of the population. And there are fanatical Copts as well. Most Egyptians, however, respect the coexistence that has always prevailed in their country and will, they hope, continue to endure.

United States, Canada, Australia, and Western Europe. Expatriate Copts publicly lament the problems of Egyptian Christians, sometimes at the risk of creating trouble for them.

The Copts do not consider themselves a minority

How many Copts are living in Egypt today? The number has been debated a great deal in recent years. Government censuses estimate that about 6 percent of the population, or roughly 3.5 million people, are Copts. The church often claims considerably higher numbers: 10 million or more. They are unevenly scattered across the country, constituting as much as 20 percent of the population in the Asyut region, but barely more than 1 percent in parts of the Nile Delta.

But whether they are 3 or 10 million, the Copts cannot be considered a negligible minority. They matter in today's Egypt, and are an integral part of its identity. They have always contributed actively to the economic life of the nation, and since the beginning of this century have been a continuous presence in every domain of Egyptian culture, whose dynamism makes itself felt across the Arab world. Copts are found in the most successful business sectors: the pharmaceutical and automotive industries, textiles and fashion, commerce, hospitals, construction, and tourism (50 percent of all travel agencies are owned by Copts). Many have professional careers (in medicine, pharmaceutics, accounting), but we should not forget that there are many villages of Upper Egypt where a traditional Coptic peasantry survives, and that most of Cairo's unfortunate rag-pickers are Coptic.

This is why many Coptic intellectuals refuse to consider their community a minority: it is inseparable from the history and fabric of Egypt. Copts and Muslims belong to the same intricate weave of multiple identities that has formed the Egyptian nation, fruit of the cultural and religious sedimentation of millennia. The current renewal of the church, energized by the vitality of the monasteries and vigorously guided by Patriarch Shenuda III, has made the ecclesiastical hierarchy the privileged representative of a Coptic

Above: among contemporary Egypt's poor are many Copts; indeed, the great majority of the 50,000 *zabbalin,* the ragpickers and traditional refuse collectors of Cairo, are Christian. Today, a Coptic "consecrated daughter," Sister Sarah, is a leader in the fight to provide services to this disadvantaged population, closely supported by the church.

"Human beings, especially the most disadvantaged, must be encouraged to develop their civic sense of Egyptian nationality. We, for our part, wish to begin with the children. What is the healthy way to bring God to children, to enable them to build society? We must do exactly the opposite of what the Islamic fundamentalists want; we have a counter-program: we must establish a common front of pluralistic Egyptians—of Muslims and Christians who say 'no' to those who want to destroy what we have always been."

Amin Fahim, Coptic lawyer, president of the Christian Association of Upper Egypt

Below: Coptic children wearing choir robes. The liturgy likens them

"nation." Many Copts see this religious revivalism as the appropriate response to the extreme Islamic model that they fear may someday be imposed on Egypt. Still, such a resurgence of religious fervor and identity, despite its many indisputably positive aspects, should be viewed with caution, for it cannot help but slow down modernization, marginalizing the laity in the evolution of the community and inhibiting its involvement in political life.

to angels. Overleaf: the Monastery of Saint Paul, on the Red Sea coast.

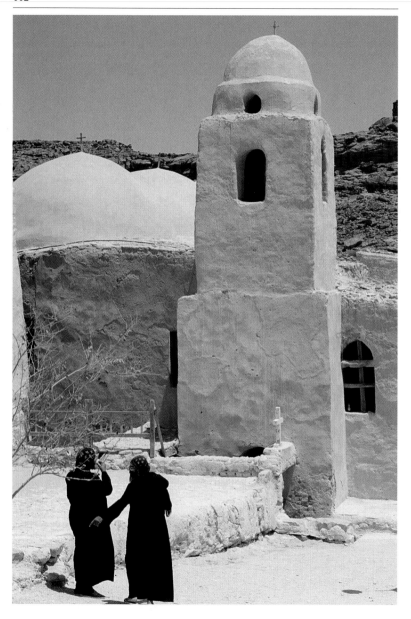

DOCUMENTS

Origins of the Egyptian church

According to tradition, Christianity came to Egypt when the Holy Family fled there from Judea to escape Herod. Saint Mark the Evangelist preached the Gospel at Alexandria and is considered the founder of its Christian community. Whether or not this patrimony can be confirmed by the historical record, it is deeply ingrained in the cultural memory of the Copts.

Previous page: a monk displays an icon at the Red Monastery.

Saint Mark

The historical Mark was Egyptian by birth and has always been the central figure in the Coptic calendar of saints.

Mark, also known in scripture as John Mark, was born in Cyrene, capital of Cyrenaica, in North Africa, some time after the dawn of the first century into a comfortable Jewish family engaged in agriculture…Owing to Berber inroads, the family decided to emigrate to Palestine, where they settled at a new home in Jerusalem just about the time when Jesus began to emerge into prominence…As a young man, [Mark] became captivated by the teaching of Jesus and was baptized by Peter, to whom he was related through Peter's wife.

Mark's mother received Jesus, who feasted in her house, and later she opened her residence to his faithful followers, who congregated there for daily prayers. In this way, Mark's house became the first Christian church in history, and it was there that the Holy Spirit descended on the disciples after the Ascension of Jesus…

Mark returned at an unknown date to the country of his birth…Coptic tradition teaches that [Mark], after performing miracles of healing in Cyrenaica, followed the road to Alexandria… Arriving at Alexandria totally exhausted, Mark found a cobbler named Anianus and asked him to mend a broken strap of his tattered sandal. When the cobbler took an awl to work on it, he accidentally pierced his finger and cried aloud in Greek, *"Heis ho Theos,"* that is, "God is One." Mark's heart fluttered with joy at this utterance, which betrayed the possibility of his companion's monotheism, thus opening the door for the

preaching of the New Kingdom. After miraculously healing the man's wound, Mark took courage and delivered the good tidings to the hungry ears of his first convert. In this manner, the initial spark was struck, and the first stone in the foundation of the Coptic church was laid. The cobbler invited the apostle to his home, and he and his family were baptized. There followed other baptisms, and the faithful multiplied. So successful was the movement that the word spread around that a Galilean was in the city preparing to overthrow the idols. Popular feelings began to rise, and people sought out the stranger. Scenting danger in the air, Mark ordained Anianus bishop, with three presbyters (Mylios, Sabinos, and Sardinos), and seven deacons to watch over the growing congregation in case anything befell him. Afterward, he seems to have undertaken a journey to Rome in response to a call for assistance from Paul. Writing to Timothy, Paul said, "Get Mark and bring him with you; for he is very useful in serving me" (2 Tm. 4:11)…Mark returned to Alexandria after visiting Rome, possibly several years after the synod and in all probability after the martyrdom of both Peter and Paul, possibly in the year 64…

The Christian population of Alexandria was multiplying at a considerable rate, and rumors ran through the city, as on Mark's first visit, that under the leadership of Mark the Christians were threatening to overthrow the ancient pagan deities. This possibility inflamed the fury of the idolatrous populace. A hostile mob unremittingly hunted the evangelist. In 68, Easter fell on the same day as the festival of the popular pagan god Serapis. A large group congregated in the temple to Serapis on the occasion and decided to move against the Christians, who, with Mark leading their prayers, were celebrating Easter at their Bucalis church. The mob forced its way into the church and seized the saint, put a rope around his neck, and dragged him about the streets. With the connivance of the authorities, Mark was incarcerated for the night. It is said that the angel of the Lord appeared to him during the night and fortified him to bear the approaching martyr's crown. On the following day, he was again dragged over the cobbled roads of Alexandria, his body becoming lacerated and his blood covering the ground, until he finally died. But the mob would not stop at that; they wanted to cremate his mutilated body so that there would be no remains for his followers to honor. Though the sources are silent on the matter, it appears that Mark was decapitated after his martyrdom. At this point, however, a violent wind began to blow, and torrential rains poured down on the populace, which dispersed. The Christians stealthily removed the body of the saint and secretly buried him in a grave that they speedily carved in the rock under the altar of the Bucalis church, which has carried his name ever since.

Mark probably wrote his Gospel some time between his two sojourns in Alexandria.

It is sometimes suggested that Peter dictated it to him. It is true that Mark, the enlightened and able scholar, interpreted for Peter, the simple fisherman, in Rome. But this does not imply that Mark only recorded for Peter, his senior in years, though it is quite conceivable that all the disciples pooled details of oral information about the Lord's sayings and acts, which Mark may have legitimately incorporated into his work.

Consequently, this Gospel, like the other Gospels, must have contained eyewitness source material of Petrine origin.

The idea has been advanced that the Gospel was written in Latin at the time of the martyrdom of Peter and Paul or shortly thereafter, but this is a very questionable hypothesis, because the Gospel is said to have been known some twelve years after the Crucifixion, which fixes its composition around the year 45, whereas the martyrdom of the two saints occurred in 64. Apparently Mark must have written his Gospel in the popular *koine* Greek without relying on literary brilliance. All he wanted to produce was a forceful text marked by simple directness, vivid scenes, and a depth of feeling to captivate public attention with its unique fascination. According to Papias, bishop of Hierapolis, who wrote before the middle of the second century, there had existed an early Aramaic collection of the sayings of Christ known as the *Logia*, which must have furnished the evangelists and the apostles with a common source. The third-century papyri discovered at Oxyrhynchus in Middle Egypt have been found to contain fragments from the *Logia* that are identical with passages from the Gospels. It is possible that the Gospels in turn were copies of more ancient originals. According to modern scholars, however, dating the Gospel of Mark from the sixties of the first century is given priority; it must have been circulated while some apostles were still living, and it could not have differed from their own recollection of Jesus. The consensus among New Testament commentators is that the Gospel of Mark must be regarded as authentic history. Whatever the truth may be, it is certain that Mark brought his Gospel with him to Alexandria, and though his Greek version must have fulfilled its purpose in a city that was preponderantly Greek, the suggestion is made that another version in the Egyptian language could have been prepared outside the metropolis for the benefit of native converts who may not have been conversant with the Greek tongue.

Aziz Suryal Atiya,
The Coptic Encyclopedia,
vol. 5, 1991

The patriarch Demetrius

The Patrologia Orientalis, *or* History of the Patriarchs of the Coptic Church of Alexandria, *is a collection of accounts of the lives of the Eastern Fathers of the Church, compiled by the Christian Severus (Sawirus ibn al-Muqaffa), bishop of Ashmunein, who wrote in Arabic around 955–87. The 12th patriarch, Demetrius, lived at Alexandria between 189 and 231, during the flowering of the Catechetical School. The Roman emperor was Septimius Severus, who persecuted Christians.*

When the patriarch Julian was dying, an angel of the Lord came to him in a dream, on the night before his death, and said to him: "The man who shall visit thee tomorrow with a bunch of grapes shall be patriarch after thee." Accordingly, when it was morning, a peasant came to him, who was married, and could neither read nor write; and his name was Demetrius. This man had gone out to prune his vineyard, and found there a bunch of grapes, although it was not the season of grapes; so he brought it to the patriarch. And the patriarch Julian said to the bystanders: "This man shall be your patriarch; for so the angel of the Lord last night declared to me." So they took him by force, and bound him with iron fetters.

And Julian died on that very day; and Demetrius was consecrated patriarch...

He had a gift from God, which was that when he had finished the liturgy, before he communicated any one of the people, he beheld the Lord Christ, giving the Eucharist by his hand; and when a person came up who was unworthy to receive the Mysteries, the Lord Christ revealed to him that man's sin, so that he would not communicate him. Then he told that man the reason, so that he confessed his offence. And Demetrius reproved him, and said: "Turn away from thy sin which thou dost commit, and then come again to receive the Holy Mysteries."

When this practice had continued a long time, the faithful of Alexandria left off sinning for fear of the patriarch, lest he should put them to open shame; and each one said to his friend or his kinsman: "Beware lest thou sin, lest the patriarch denounce thee"...

O my friends, this Father was chosen by God, and in his courage and valour was braver than those that slay lions; as one of the doctors says: "The brave man is not he that kills wild beasts, but he that dies pure from the embraces and snares of women." Blessed is this saint, for his degree is exalted! Like Joseph in the house of the Egyptian woman, when she solicited him on every occasion that she could, so Demetrius fought against his desires every day and night until his battle was finished, and preserved his chastity and his right faith throughout his life.

Demetrius remained patriarch for forty-three years. In his time there was a disturbance at Alexandria, and the emperor Severus banished him to a place called the quarter of the Museum; and there he died on the 12th day of Barmahat, which, I believe, was the day of the manifestation of his virginity.

Now in the reign of the emperor Severus many became martyrs for the love of God. Among them was the father of a man named Origen, who learned the sciences of the heathen, and abandoned the books of God, and began to speak blasphemously of them. So when the Father Demetrius heard of this man, and saw that some of the people had gone astray after his lies, he removed him from the Church.

In these days also the martyrs Plutarch and Serenus were burnt alive, and Heraclides and Heron were beheaded. Likewise another Serenus, and the woman Herais, and Basilides; and Potamiaena, with her mother Marcella, who suffered many torments and severe agonies; also Anatolius, who was the father of the princes, and Eusebius, and Macarius, uncle of Claudius, and Justus, and Theodore the Eastern; all these martyrs were kinsmen. There was also another virgin named Thecla. Now Basilides was a soldier, and he came forward of his own free will; and when they questioned him he replied: "I am a Christian because I saw three days ago in a dream a woman who appeared to me, and placed upon my head a crown from Jesus Christ." Thus Basilides obtained the crown of martyrdom; and so likewise a great number were martyred; for Potamiaena was seen by all of them in dreams, and encouraged them to have faith in the Lord Christ, so that they received the crown of martyrdom.

From Severus (Sawirus ibn al-Muqaffa), *History of the Patriarchs of the Coptic Church of Alexandria* (*Patrologia Orientalis*, vol. I), trans. Basil Evetts, Paris, 1904

The Desert Fathers

The tradition of calling the wise bishops and monk-saints of the early church "Fathers" arose in Egypt in the 4th century. The word used was the Coptic aba, *from the Greco-Aramaic* abbas, *which later became the English word abbot. The concept of a "spiritual paternity" was adopted by Christianity from the old polytheistic religion of pharaonic Egypt. It has been a profound influence on Coptic spirituality.*

Mary, Mother of God

At the contentious Council of Ephesus in 431, Cyril, bishop of Alexandria, defended the use of the title Theotokos, *Mother of God, for the Virgin Mary. He was opposed by the Nestorian faction, but won his point.*

I see this joyful assembly of holy bishops who, at the invitation of the blessed Mother of God, Mary ever Virgin, have gathered here with enthusiasm. And although I am sad, the presence of these holy Fathers fills me with joy. Among us are fulfilled the sweet words of the psalmist David: "Behold how good and sweet it is, brethren, to dwell together in unity."

So we hail you, mysterious holy Trinity, who have brought us all together in this church of holy Mary Mother of God.

We hail you, Mary, Mother of God, sacred treasure of all the universe, star who never sets, crown of virginity, sceptre of the orthodox law, indestructible temple, dwelling-place of the incommensurable Mother and Virgin, for the sake of the one who is called "blessed" in the holy Gospels, the one who "comes in the name of the Lord."

We hail you, who held in your virginal womb him whom the heavens cannot contain; through whom the Trinity is glorified and worshipped throughout the earth; through whom the heavens exult; through whom the angels and archangels rejoice; through whom the demons are put to flight; through whom the tempter fell from heaven; through whom the fallen creation is raised to the heavens; through whom the whole world, held captive by idolatry, has come to know the truth; through whom holy baptism

is given to those who believe, with "the oil of gladness"; through whom churches have been founded throughout the world; through whom pagan nations have been led to conversion.

What more shall I say? It is through you that the light of the only-begotten Son of God has shone "for those who dwelt in darkness and in the shadow of death"; it is through you that the prophets proclaimed the future, that the apostles preach salvation to the nations, that the dead are raised and that kings reign, in the name of the holy Trinity.

Is there a single person who can worthily celebrate the praises of Mary? She is both mother and virgin. What a marvel! A marvel which overwhelms me! Who has ever heard it said that the builder was prevented from dwelling in the temple which he himself built? Should one criticize him who gave his servant the title of mother?

Thus the whole world rejoices. May it be given us to worship and adore the unity, to worship and honour the indivisible Trinity, by singing the praises of Mary ever virgin, that is the holy church, and those of her Son and immaculate Spouse, to whom be glory for ever and ever, Amen.

<div style="text-align: right">

Cyril of Alexandria,
Homily Given at the Council of Ephesus,
431, in Adalbert Hamman,
How to Read the Church Fathers,
trans. John Bowden and
Margaret Lydamore, 1993

</div>

The Desert Fathers among the beasts of the wilderness

Many tales are told in the ancient documents of the early saints of the desert. Among their miraculous powers, they were said to have the ability to communicate with animals.

When Anthony startled an ostrich and its young into flight, he heard it say, "Throw stones, so as not to be caught." Macarius heard a famished wolf cry to the heavens for food. He was shocked—and so was the wolf—that the brothers around him did not understand what it had said. The ancients understood animals very well. Some lived openly and harmoniously with them. Agathon discovered a cave where he decided to live. A large snake who was already there wanted to make way for him, but the old man begged him to do nothing of the sort, saying: "If you leave, I'll leave too." So they remained there together and ate the sap of a nearby sycamore. Among the other anchorites who lived among the animals, Theon frequented buffalo, onagers, gazelles and other herds of animals, "which delighted in him." Postumianus the traveler, of whom Sulpitius Severus recounts tales of a voyage to Egypt, met anchorites who habitually fed either a lion—with fruit!—or a she-wolf. The she-wolf came on a regular basis to eat with a monk in his cell, at six o'clock, nine o'clock, or in the evening, depending on the rules of fasting. She never mistook the time. Unfortunately, one day when the monk was away, she carried off a loaf of bread and did not dare return for several days. But having shown her regret, she was pardoned for her error and returned to her habit of coming to eat with the anchorite each day at the appointed hour.

<div style="text-align: right">

L. Regnault,
*La Vie quotidienne des Pères du désert en
Egypte au IVème siècle*
(*The Daily Life of the 4th-Century
Desert Fathers in Egypt*),
1989

</div>

Pachomius builds a monastery and founds a congregation

It so happened that since the brothers had grown in number at the monastery of Tabennisi, Pachomius decided that they were in the right place, and began to implore God on the subject; he was answered by the following revelation: "Arise, go the north to the abandoned village situated downstream from you, known as Phbu, and build a monastery for yourself there, which will become a base for you and enjoy renown for many centuries to come." He arose at once, brought several brothers along with him and went to the village to the north, spending a few days there with the brothers while building the monastery walls; later he built a small banquet room with the permission of the bishop of Diospolis; he also built houses. He set up the household heads with their seconds-in-command, according to the rules of the first monastery. As for himself, he oversaw both monasteries night and day, as a servant of the Good Shepherd.

Les Vies coptes de saint Pachôme et de ses premiers successeurs (*The Coptic Lives of Saint Pachomius and his First Successors*), 1943

Monasticism in the modern era

Life continues today in an ancient desert monastery, with some changes and some continuities.

Today, an essential problem posed to any historian of ancient monasticism is to ascertain whether it has a message for candidates for monkhood in our century, and if so, what it is. We can *a priori* assume that it can tell us a great deal, for in all times of monastic revival people have felt the need to look to the monks of the 4th and 5th centuries, to examine their *Maxims,* to contemplate their daily lives—and that of Anthony in particular. But according to which criteria may we plumb these ancient treasures? And with what reservations and adaptations? For we are contingent upon our times and our status as Westerners, with Western preoccupations.

At the request of the late Orthodox Patriarch Cyril, the Monastery of Saint Macarius was reopened in 1969 by a dozen hermit monks…The monks of his monastery intended to remain faithful to ancient tradition, as far as possible, while also desiring to maintain their commitment to our own times.

From 1969 to 1983 they flourished; in the space of 14 years their number rose from 12 to almost 120. In other words, their program of reconstructing the past in Egypt was accepted as perfectly valid for the present…

In the 4th and 5th centuries candidates for monastic life were for the most part uncultured, even illiterate. But many candidates seeking admission to the Monastery of Saint Macarius today have a university education and many have practiced a profession. They include professors, doctors, engineers, etc. The median age of the community is around thirty-five; monastic life at Saint Macarius clearly satisfies the aspirations of young people today…

At the monastery the offices, sung in Coptic or in Arabic, scarcely vary from one day to the next, so that a regular participant might sing most of them by heart, with eyes closed in the semi-darkness. The use of such familiar services was very convenient in the days when people did not know how to read, as was the case in the 4th century.

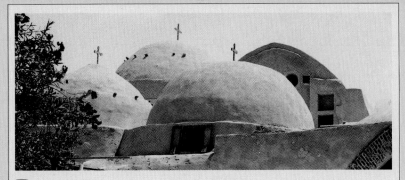

Deir Amba Bishoi (the Monastery of Saint Pschoi).

Yet it still has its charm, for such repetition itself can encourage contemplation and simplicity in the consideration of God.

However, Western reaction differs from Eastern here. In the West the frequent repetition of the same psalms, hymns, and formulas, which was embraced by a majority 20 or 30 years ago, is today less readily accepted; in general, people prefer a little more variety. And they also prefer a liturgy that is interrupted and interiorized by long moments of collective silence, according to the ancient method (as it was described, for example, by Cassian for the monks of Egypt), rather than the strict recitation of a list of formulas. Worshipers want fewer texts, and to savor each at greater length...

Part of the office takes place in each monk's cell. Nones is recited in the refectory by the assembly of the monks before the main meal, which is taken communally. Only the offices of morning, evening, and vespers are celebrated in one of the monastery chapels. The regulation of participation is much more fluid than in the West.

A spontaneous delegation of the community assures the celebration of the office, and the monks come and go pretty much at their own pace. Undoubtedly, this system is better suited an Eastern concept of freedom... Thus, on the one hand, the monks of Saint Macarius today are not bound to a tradition that promotes an attitude of distance from communal prayer, as the Egyptian fathers of the 4th and 5th centuries probably were. On the other hand, they strive to take responsibility for themselves, especially with regard to the influence of the Holy Spirit, which suggests to each monk the form of prayer most pertinent to him. And this is not necessarily the same as that of his neighbor. Some monks are more given to solitary prayer, others to communal prayer; they coexist in the same monastery without problems, provided everyone agrees to practice both kinds of prayer, according to the measure the spiritual Father provides to each.

L. Leloir, "Humour, travail et science en Orient" (Humor, Work and Science in the East), *Acta Orientalia Belgica V,* 1988

The echoes of ancient Egypt

Coptic culture derives many traditions from pharaonic Egypt, from the Greeks who founded Alexandria, and from the influences of neighboring peoples. Among the most visible vestiges of the ancient world in the modern are the Coptic language and calendar, and elements of its art style.

Coptic language, writing and literature

Coptic is the language of the pharaohs, inherited by the Christians of Egypt and put to use by them in a rich spiritual literature.

Coptic is the original language of Egypt. It is, in fact, the oldest known living language in the world, although during the Middle Ages it ceased to be a functioning language (it had mostly become extinct by the end of the 13th century), and today its use is fossilized in church liturgy. Coptic is the last stage of the language spoken in Egypt in pharaonic times, as can be seen in written documentation that dates to as early as the dawn of the third millennium BC. The last original text drafted in Coptic before it faded is the poem called the *Triadon,* composed a little after 1300. We may say that the written language spans no less than 4,300 years. From a linguistic perspective, this is unique.

Egypto-Coptic belongs to the family of languages known as Hamitic-Semitic (spoken by the descendants of Ham and Shem, the sons of Noah), or Afro-Asian, which includes five subgroups, equally distinct from one other:

1. The Semitic group: ancient Assyro-Babylonian (Akkadian), Ugaritic, Canaanite (Phoenician, Moabite, Hebrew), Aramaic, Syriac, Arabic, Ethiopian, Amharic, etc.;
2. The Libyan-Berber group: Tuareg, Chleuh, Tamachek, Zenaga, Kabyle, Rif, Siwi, and others;
3. Egyptian-Coptic;
4. The Cushitic group: the numerous languages of the populations of the Upper Nile, such as Somali, Oromo,

Saho-Afar, Agau, Beja, Burji, Geleba, Gimira, Janjero, Konso, Kaffa, Maji, and Sidamo;

5. The Nigerian-Chadic group: including countless dialects of Nigeria and Chad, in particular, Hausa.

There are lexical and grammatical affinities among these languages, which bear witness to their common origin.

Coptic descended from pharaonic Egyptian, but it inherited none of the literary forms of the language as found in antiquity. It comes from the unwritten language spoken by peoples of Egypt in the Hellenistic era, which was fragmented into various dialects. This is quite different from the literary language, whether the traditional Egyptian reserved in particular for use in sacred texts, or the demotic used especially (but not exclusively) in practical writing or profane literature. These polished languages were written either in hieroglyphics, or in cursive scripts, from which the writing known as hieratic or demotic derived.

Hieroglyphic writing was an extremely complex system involving several hundred signs (and in the Ptolemaic period, even several thousand), without vowels. Coptic writing represented a revolution away from this. Attempts to write Egyptian using the Greek alphabet date to as early as the 3d century BC, and texts in Old Coptic have been found in esoteric places in the first two centuries AD. Nonetheless, the Christian church was beginning to be organized into a structure in the 3d century, and we should probably consider it as the originator of Coptic writing. Coptic uses a form of the Greek alphabet called uncial, with six or seven additional signs (depending on the dialect) borrowed from demotic and used to note sounds in Coptic that do not exist in Greek, such as *tch*. Clearly, this alphabet was a more flexible medium for the diffusion of the Bible than the ancient hieroglyphic system.

To speak of a "Coptic language" is a bit reductive. In fact there were two vehicular languages, promoted to the rank of written languages by the 3d century AD: in the south Sahidic, from *Said,* the Arabic name for Upper Egypt—and in the north, Bohairic, from *Bohaira,* the Arabic name for the Delta. Aside from these two widespread languages, there were local dialects, in particular, those of the Nile Valley. These are, from south to north: Lycopolitan, Akhmimic, Mesokemic (Middle Egyptian), and Fayumic. At some periods these were also written. Most of the extant masterworks of Coptic literature are

Jesus in the Synagogue, miniature in a Coptic Gospel, written in Bohairic, 1179–80.

in Sahidic, but Bohairic supplanted it as the liturgical language in the Middle Ages.

Ashraf I. Sadek, editor-in-chief of the magazine *Le Monde Copte* (*The Coptic World*), writing in issue 24, 1994, says this of the Copts' attitude toward their liturgical language: "For the Copts in Egypt, the use of this language is above all a cultural focal point and a part of their identity. We must not lose sight of the fact that Arabic is the 'sacred language' of the Muslims, extremely marked by Islam, and that it is not easy for non-Muslims living on Arab soil to express their differences in a language so impregnated with its religion. The Coptic language maintains a bond between the community and its past, and an affirmation of its affiliation with Egyptian soil. In the current situation, we may easily understand that this aspect is of capital importance to the Copts remaining in Egypt."

Christian Cannuyer

The Coptic calendar

The Coptic calendar derives from the pre-Christian Alexandrian system. It adopted the Roman (Julian) adjustment that inserts a leap year every four years, but did not follow the further revision imposed in the 16th century by the Roman Catholic pope Gregory XIII. The Coptic era begins on August 29, 284 of the Common Era (CE, or AD), the date established under the Roman emperor Diocletian as the point of departure for the calculation of Easter. Hence it is also known as the Diocletian era, or the Era of the Martyrs. Thus, the year 2000 in the West corresponds to the year 1716/1717 of the Era of Martyrs. There is evidence that this calendar was in use by the beginning of the 4th century. It has 13 months: 12 months of 30 days each and an intercalary Little Month of 5 days at the end of the year (6 days in a leap year).

The year begins in the autumn, originally the season when the Nile River flooded. The names of the Coptic months derive from Greek transcriptions of Egyptian month names of the late pharaonic period (between 664 and 305 BC). Although they evoke pagan holidays and divinities, they are still used today by the peasants of the Nile Valley, Christians and Muslims alike.

Coptic Christmas is celebrated on January 7, as it is in the Eastern Orthodox church, and Easter and other Christian movable feast days are calculated according to the Orthodox calendar.

Some aspects of Coptic painting

The figurative arts of the Christian East are better known to us through ivories, manuscripts, textiles, than by monumental works, and this is particularly true of Coptic art...Yet when Christianity spread in Egypt, numerous churches were erected. There were important buildings in the large cities such as Alexandria, Arsinoë, Oxyrhynchos, Antinoë, or in famous pilgrimage centers like that of St. Menas...When the temples were closed by order of the Emperor Theodosius, churches were built within their precincts; ruins of these basilicas have been found in most of the great pagan sanctuaries at Luxor, Karnak, Denderah, Edfu and others. The name by which we designate the funerary temple of Queen Hatshepsut, Deir el-Bahri, which means the convent of the north, retains to this day the memory of the Christian buildings erected there...

Two Christianities can be said to have existed in Egypt. One, that of Alexandria, learned, versed in Greek philosophical thought, interested in theological discussions, which used only the Greek language; the other, that of the common people, of the population of rural sections or of cities which were further removed from the important centers and who spoke Coptic for the most part. From these people arose the ascetics who, following the example of St. Anthony and of St. Paul the Theban, lived a solitary life of religious contemplation...Their faith was an ardent though a simple one...with a love for the miraculous...The biographies of the desert fathers, the lives of the martyrs, give us a clear picture of the Coptic mind; we find this same image in looking at their paintings.

At first the Coptic artists seem to have imitated fairly closely the late classical style of the metropolis, judging from the paintings found at El-Bagawat,...the Hellenistic taste for allegorical figures survives here in the personifications of peace, prayer and justice...

[A] change...is much more apparent in the paintings of the sixth and seventh centuries. Nationalism had been growing rapidly in Egypt, and Christianity soon took the form of political opposition to the Greek civilization...The Manichaeans may also have been instrumental in introducing Eastern and particularly Sasanian elements into Egypt...

[An] interest in apocryphal scenes... finds its expression in the paintings of Bawit, the monastery founded by Apa Apollo in the beginning of the sixth century...The walls of the small funeral chapels are covered with figured representations and decorative designs...In *The Anointment of David*, Samuel holds a wand instead of the horn or vase containing the oil, and this difference has been ascribed to the frequent use of the magic wand, in Egypt, in various miracles, divinations or predictions...

All the paintings of Coptic churches or monasteries do not have a religious character; decorative compositions have also been used, some of which bear witness to the survival of late classical themes despite the estrangement of the Copts from the Greeks...painted around the chapel walls of Bawit baskets of fruit or birds alternate with wined figures in medallions. These figures are not angels; some of the inscriptions clearly designate them as personifications of virtues such as faith and hope...Other representations... reveal models which must have come from Persia; such is the lion hunt, a familiar theme in Sasanian art...

All these figures...[have] an arresting quality in the depth of feeling which one can see in their intent gaze...and they reveal that interest in portraiture which runs straight through Egyptian art...they express that ardent mysticism which characterized the Coptic people.

Sirarpie Der Nersessian,
Some Aspects of Coptic Painting,
in *Coptic Egypt*,
Brooklyn Museum, 1944

On earth as it is in heaven

The Copts are passionate both in their religious commitment and in their sense of secular identity.

The formation of the liturgy

The liturgy lies at the heart of Coptic spiritual practice. It is lengthy and preserves songs and chants whose origins, it is believed, lie in the sacred hymns of ancient Egypt. Some, we may imagine, were intoned by the priests in the temples of the old religion.

The ancient Eucharistic liturgy of the See of Saint Mark was translated into Coptic and preserved under the name of Cyril. [Over time] monasticism exercised ever greater influence on it. In the Coptic church, more than elsewhere, the celebration of the divine office drew upon the monastic tradition, with its long, intoned psalms, its pronounced scriptural character, and its distaste for too much overt ritual. The liturgy is imbued with this tradition. But we must also take into account the Syrian influence, which is often overlooked...

During the course of the 12th and 13th centuries a succession of energetic patriarchs undertook a vast reform: the dialect of the Delta (Bohairic) was used more and more exclusively; in consequence, certain foreign formulas that had been translated and preserved in the dialect of upper Egypt (Sahidic) gradually disappeared. The revision of the liturgical books undertaken (in the 16th century) were preserved in reformed canons and in the vast encyclopedia of Abul-Barakat. The ritual owes its current form to Patriarch Gabriel V at the beginning of the 15th century. Three Eucharistic anaphorae are retained; in practice, the anaphora of Saint Basil takes precedence over the old Alexandrine anaphora of Saint Cyril, which is too long and difficult to chant...

A ornate cross in a Bohairic Coptic Gospel, 1179–80.

Arabic has long been used together with Coptic in the celebration of the liturgy; songs and hymns of praise have always been preserved in Greek. But under these various cloaks the Coptic liturgy today remains in essence the one established by the monks of Saint Macarius in Wadi Natrun during the time when the first patriarchs of Alexandria lived among them.

<div style="text-align: right">

H. I. Dalmais,
Les Liturgies d'Orient
(*The Liturgies of the East*), 1958

</div>

The mystery of the Eucharist

Here is a passage from the divine service.

THE CELEBRANT: "You are in truth Holy, O God our Father, You who created us and placed us in the garden of Eden. When we disobeyed Your commands because of the snake, we fell from eternal Life and were exiled from joyous Paradise. But You did not abandon us, and You visited us through Your Holy Prophets, and, at the end of time, You appeared to us as we sat in the dark, in the shadow of death, through Your Only Son, God the Savior, Jesus Christ, who was born of the Holy Spirit and the Virgin Mary."

THE FAITHFUL RESPOND: "Amen."

THE CELEBRANT CONTINUES: "He was made flesh and became man, and He taught us the road to salvation. He granted us the grace of heavenly birth through water and the Holy Spirit. He united us as a people. He sanctified us through Your Holy Spirit, He who so loved His fellow man on this earth that He sacrificed Himself for our redemption, descending into the dark kingdom of death that governed us and kept us in chains because of our sins; He descended into Hell by His Cross."

THE FAITHFUL: "Amen, we believe!"

The Coptic patriarch Shenuda III consecrates the Host, Easter 1994.

THE CELEBRANT: "He was raised from the dead on the third day. He rose to the Heavens, sat at Your right hand, O Father, and He appointed the day of retribution when He shall return to judge the world justly and render unto each according to His works."

THE FAITHFUL: "By your mercy, O Lord, and by our iniquity."

THE CELEBRANT: "And He left us the great mystery of His bounty."

The celebrant takes the smoke of the incense in his hands and brings it toward the Holy Gifts.

THE CELEBRANT: "For having resolved to give Himself over to death for the life of the world…"

THE FAITHFUL: "Amen, we believe!"

THE CELEBRANT: "He takes the bread in His pure, blessed, and life-giving hands.

THE FAITHFUL: "We believe Him in truth. Amen."

THE CELEBRANT: "He raised His eyes to the Heavens toward You, His Father, the Lord of all things [*sign of the cross on the bread*], He gave thanks…"

THE DEACON: "Amen!"

The celebrant makes a second sign of the cross on the bread.

THE CELEBRANT: "He blesses it…"

THE DEACON: "Amen!

The celebrant makes a third sign of the cross on the bread.

THE CELEBRANT: "He blesses it…"

THE DEACON: "Amen!"

THE FAITHFUL: "We believe Him in truth, we confess our faith and glorify Him."

The celebrant gently divides the bread with his thumb, without using the nail, without separating the morsels and without touching the Aspadikon *(the central part, depicting the Lamb).*

THE CELEBRANT: "He breaks it…[*the celebrant kisses the bread*] and gives it to his most beloved Apostles, saying, "Take this bread and eat of it, all of you, for it is my Body…[*the celebrant lightly divides, without separating it, the upper portion of the bread, which symbolizes the Head of Christ, and places it all on the paten*]…which was broken for you and many others for the remission of your sins. Do this in remembrance of me."

THE FAITHFUL: "In truth it is so."

From the Liturgy of Saint Basil

Milad Hanna and the Seven Pillars of Egyptian identity

In the modern era, the Copts no longer define their culture purely in religious terms. Milad Hanna (b. 1924) is one of the Coptic political men most visible in present-day Egypt. Mayor of the small seaside town of Marina, west of Alexandria, he has written many books on his country, including, in 1989, Les Sept Piliers de l'identité égyptienne (The Seven Pillars of Egyptian Identity). Many times elected to Parliament, he was imprisoned under Sadat for his opinions.

The Muslims are very attached to their religion, and the Copts to theirs, and I have nothing against this. What I oppose is that fundamentalist Islam should take over Egyptian Islam, so that the latter disappears. Egyptian Islam is alive in the people; it is alive in me, and in all the Copts and Egyptians of my generation…But the new generation of Copts turns in upon itself, into the church and its religion, neglecting culture, while the Muslims are educated and indoctrinated by the funda-mentalists…Egyptian identity was forged by time and space. Time,

meaning history, is made up of the four strata of civilizations: the pharaonic, Greco-Roman, Coptic, and Islamic. The diversity and pluralism of these many and varied civilizations create the richness and originality of Egypt. Spatially, in terms of its geographical position, Egypt is at the heart of the Arab world; it commands the Mediterranean and represents an important part of Africa. These three geographical characteristics add to the four historical components and form what I call the "seven pillars" that forge Egyptian identity. These seven pillars are present in each Egyptian, whatever his religious beliefs. Hence the Egyptians are culturally different from their neighbors... In Egypt, there is an Egyptian Islam: its face is Sunni, its blood Shiite, its heart Coptic, its bones pharaonic.

Remarks edited by Ashraf I. Sadek in *Le Monde copte* (*The Coptic World*), no. 25–26, 1995

Painted plaster statuette of a woman, probably from Ashmunein, 4th–5th century.

The Copts as seen by the West

By the time of the Crusades, Western travelers to Egypt began to bring accounts of the "Cophts" back to Europe. Ever since, they have remained fascinating to Europeans.

A 13th-century Western bishop considers the Copts

One of the most famous chronicles of the Holy Lands in the Middle Ages is that of the crusader Jacques de Vitry. He was bishop of Acre (now in Israel) at the time of the 5th Crusade, and witnessed its failure in Egypt. He described the Copts in his Historia Orientalis, *written in 1220. He called them "Jacobites," after Jacob Baradaeus, the Monophysite bishop who had reorganized Eastern churches in the 6th century. The book expresses a medieval Western contempt for Eastern Christians, who were to be liberated by the Crusades from the Muslim yoke, but who were nevertheless considered heretics. Vitry criticized several practices: circumcision, the replacement of the aural confession to a priest with incense confession directly to God, tattooing, and in particular the supposed Monophysitism of the Copts. Nonetheless, he did try to appreciate the Christology of the Copts objectively. For perhaps the first time, a European author recognized that the faith of the Egyptian Christians in Christ as true God and true man was in substance the same as that of the West.*

Ever since the Enemy sowed discord in them, and blinded for a long time by a lamentable and miserable error, most of them practice the circumcision of their newborns of both sexes, in the manner of the Saracens. They do not wait for the grace of baptism to make the circumcision of the flesh unnecessary, just as in the blossoming of the fruit the flower fades…Another of their errors is that they do not confess their sins to the priests, but to God alone, in private, placing incense near themselves in a hearth, as if their sins could rise

toward God along with the smoke. The wretches! They are mistaken and are ignorant of Scripture. They risk perishing through lack of doctrine, in thus hiding their wounds from the spiritual doctors, whose duty it is to tell leprosy from leprosy, and to impose, according to their estimation, penances appropriate to the sins committed… The third error of these Jacobites, in their ignorance as thick as dense fog, is that many among them brand and mark their newborn children, before baptism, with a hot iron, with which they mark their foreheads. Others mark their children with a sort of cross on the knees and temples. They think by this means, erroneously, to purify them with fire…but it is obvious that for all the faithful it is the spiritual fire, or in the Holy Ghost, that the remission of sins takes place, not in natural fire…To tell the truth, we have seen some of them living among the Saracens…bearing on their arms crosses tattooed with a hot iron, who told me that they had marked themselves with the sign of the Cross in this way to distinguish themselves from the pagans and out of respect for the Holy Cross…

When we questioned the Greeks closely…to understand why they so detest the Jacobites and avoid their company, they explained the main cause of their contempt: the Jacobites fell into a condemnable and very pernicious heresy, proclaiming that there was in Christ but one single nature, just as there was but a single person. This type of heretic was condemned and excommunicated at the Chalcedonian council. Some of them believe, in a perverse way, that Christ, after having assumed human form, no longer possessed two natures but only the divine nature residing in him. It was Eutyches, a monk originally from Constantinople, who was the author of this error…Nonetheless, although I informed myself diligently among the Jacobites to learn if it was true that they thought that there was but one nature in Christ, they denied it, compelled I know not whether by fear or some other reason.

Jacques de Vitry,
Historia Orientalis, 1220

A 17th-century German Christian visits the Copts

In his New Relation *(a kind of published travel report) Father Johan Michael Vansleb (or Wansleben, 1635–79), described the unenviable position of the Copts under Ottoman rule.*

On the 13th of the Month of *September,* I went to visit the Patriarch of the *Copties,* one of my best Friends; and because I had often entreated him to come and dine with me, I reiterated the same entreaty now again; but he answered me, that he had not been out of his house a year before for fear of the *Turks.* He complain'd that all the Patriarchs of the other Sects had the liberty to go about the Town, without fear of being disturb'd by any, to visit whom they pleas'd, and to travel whither they listed; but he was so narrowly observed by the *Turks,* that he could not so much as go out of his house, nor talk with any of other Nations openly, much less travel into any other place, but he must give them a jealousie of plotting against the State; by this means his life would be in danger.

I must needs confess that there is no Nation in *Egypt* so much afflicted as are

the *Copties,* because they have no body amongst them who deserves to be honoured for his Knowledge, or feared for his Power and Authority; for all that were rich and wealthy, are destroyed by the cruelty of the *Mahometans:* therefore the rest are now looked upon as the Scum of the World, and worse than the *Jews.* The *Turks* abuse them at their pleasure, they shut up their Churches, and the doors of their Houses when they please, upon light occasions, altogether unjust, to draw from them some sums of Money.

There was such a tyrannical Action practiced upon them in this Month of *September;* for certain Janissaries cut the Throat of a Whore, and cast her Body into the Lake *Ezbekie.* Upon that the *Soubachi* nailed up the Doors of all the Houses of the *Copties* round about, and caused them wrongfully to lay down the Sum of two thousand *Piasters* for this blood spilt, before they could have their Houses opened again, and freedom for their lives.

<div style="text-align:right">

S. Vansleb,
*The Present State of Egypt; Or,
A New Relation of a Late Voyage
into That Kingdom,
Performed in the Years 1672 and 1673,*
London, 1678

</div>

Rites and traditions of the Copts in the 19th century

The orientalist Edward William Lane traveled to Egypt between 1833 and 1835, and has left us a lively and mostly well-informed account of the Coptic community of that time.

The fame of that great nation from which the Copts mainly derive their origin renders this people objects of much interest, especially to one who has examined the wonderful monuments of Ancient Egypt…The Copts differ but little from the generality of their Muslim countrymen—the latter being chiefly descended from Arabs and from Copts who have embraced the faith of the Arabs, and having thus become assimilated to the Copts in features. I find it difficult sometimes to perceive any difference between a Copt and a Muslim Egyptian…and the Muslims themselves are often deceived when they see a Copt in a white turban…The dress of the Copts is similar to that of the Muslim Egyptians, excepting that the proper turban of the former is black or blue, or of a grayish or light-brown colour… In the towns they are usually careful thus to distinguish themselves from the Muslims, but in the villages many of them wear the white or red turban…

The Copt women veil their faces not only in public, but also in the house, when any men, excepting their near relations, are present. The unmarried ladies and females of the lower orders in public generally wear the white veil. The black veil is worn by the more respectable of the married ladies; but the white is adopted by many, from a desire to imitate the Muslim'ehs…

The Patriarch ("el-Batrak") is the supreme head of the Church, and occupies the chair of Saint Mark. He generally resides in Cairo, but is styled "Patriarch of Alexandria." He is chosen from among the order of monks, with whose regulations he continues to comply; and it is a point of these regulations that he remains unmarried. He is obliged to wear

woollen garments next to his body; but these are of the finest and softest quality, like the shawls of Kashmeer, and are concealed by habits of rich silks and cloth. So rigid are the rules with which he is obliged to conform, that whenever he sleeps he is waked after every quarter of an hour. A patriarch may be appointed by his predecessor; but generally he is chosen by lot, and always from among the monks of the Convent of Saint Anthony ("Deyr Antooniyoos"), in the Eastern Desert of Egypt, near the western gulf of the Red Sea. The bishops and principal priests, when a patriarch is to be elected, apply to the superior of the convent above mentioned, who names about eight or nine monks whom he considers qualified for the high office of head of the Church. The names of these persons are written each upon a separate slip of paper, which pieces of paper are then rolled into the form of little balls and put into a drawer; a priest draws one without looking, and the person whose name is thus drawn is invested as patriarch. Formerly a young child was employed to draw the lot, being supposed to be more under the direction of Heaven.

The property at the disposal of the patriarch is very considerable: it chiefly consists in houses, and can only be employed for pious uses. Modern patriarchs have done little more than augment their property. Generally when a Copt sells a house in Cairo, the patriarch bids for it, and no one ventures to bid against him; so that the owner of the house is obliged to part with it for considerably less than its just value.

The patriarch and bishops wear a turban of a wider and rounder form than those of other persons; much resembling the mukleh of the Muslim 'Ulama, but of the same dark colour as those of the other Copts.

Edward William Lane,
An Account of the Manners and Customs of the Modern Egyptians, Written in Egypt during the Years 1833–1835,
1836

The cult of the dead

A 20th-century scholar records a Coptic religious practice.

Among the Copts the cult of the dead is very pronounced, as it was for the ancient Egyptians. The ceremony of *Rakhma* is practiced in their honor three times a year. The relatives of the deceased gather at the monastery in which the dead have been laid to rest. Those of the Monasteries of el-Kom and el-Qurna go to Saint Theodore, which is in the desert to the south of Medinet Habu, while those from Luxor go to Saint Pachomius, those from Taud and Salamieh to the monastery where Saint Bulus and Saint Pschoi are buried. They spend the night there, distributing bread, watermelons, grilled fish, sugar cane, and the favorite foods of the deceased to the poor, in the name of the dead. The next day, after mass has been said, the mourners go to the cemetery and there await the priest and his acolytes. The priest, holding a censer, passes in front of each tomb. Mourning women name all those buried there, one by one, and after each name is pronounced, the priest says: "May God give rest to the soul of the person who rests in this tomb" and burns a few grains of incense. The officiating priest receives at least three piasters from the

relatives for each commemoration. It is not the least of his benefices.

G. Legrain,
Une famille copte de Haute Égypte
(*A Coptic Family in Upper Egypt*), 1945

In the late 19th century many European artists and writers became fascinated with a vision of the East as an exotic mixture of the deeply religious and the sybaritic. The French novelist Anatole France captured this fantasy world in Thaïs, *the story of a courtesan of Alexandria at the time of the Desert Fathers, who is converted by the ascetic monk Paphnutius. Here is his image of the desert of the Thebaid, where hermits dwelled.*

The desert, in those days, was settled by anchorites. From mud and straw, these hermits built countless huts along the banks of the Nile, far enough apart that their inhabitants could live in isolation, yet near enough that they could aid one another when necessary. Above the huts, churches raised their crosses here and there, and the monks gathered in them on holy days to attend the celebrations of the mysteries and participate in the sacraments. There were also houses right at the water's edge, where the cenobites, each enclosed in his narrow cell, met together only to better appreciate their solitude.

Anchorites and cenobites lived in abstinence, taking no food before sunset and then eating only bread with a dash of salt and wild marjoram. Some of them, burying themselves in the sand, made homes of caves or tombs and lived lives that were still more singular.

They observed vows of continence, wore cowled hair shirts, slept naked on the ground after long vigils, prayed, sang psalms, and, in a word, performed masterpieces of penitence every day. Mindful of original sin, they refused to give to their bodies not only pleasure and satisfaction but even the care that is considered necessary by those who live in the world. They believed that physical affliction purified the soul and that the flesh could receive no more glorious adornment than ulcers and open sores. Thus was the word of the prophets observed: "The desert shall be covered with flowers."

Anatole France,
Thaïs, 1890,
translated by Basia Gulati, 1976

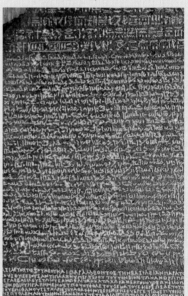

Detail of the Rosetta Stone (196 BC), showing text in Demotic script (an early form of Coptic), with hieroglyphics above and Greek below. The deciphering of this inscription confirmed the close relationship of Coptic to ancient Egyptian and made the cultures of Egypt accessible to the West.

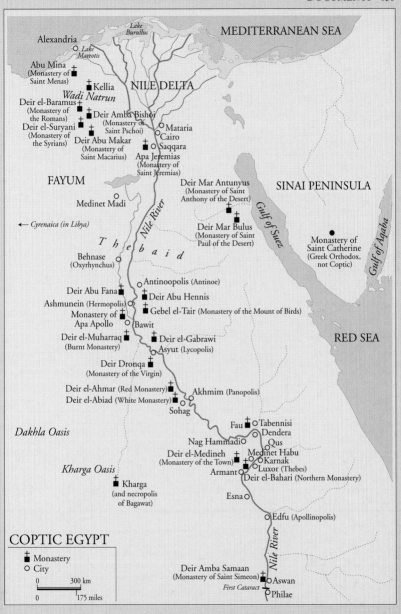

Lake Burullus

MEDITERRANEAN SEA

Alexandria

Lake Mareotis

Abu Mina
(Monastery of
Saint Menas)

Kellia

Wadi Natrun

NILE DELTA

Deir el-Baramus
(Monastery of
the Romans)

Deir el-Suryani
(Monastery of
the Syrians)

Deir Amba Bishoi
(Monastery of
Saint Pschoi)

Mataria

Cairo

Deir Abu Makar
(Monastery of
Saint Macarius)

Saqqara

Apa Jeremias
(Monastery of
Saint Jeremias)

FAYUM

SINAI PENINSULA

Deir Mar Antunyus
(Monastery of Saint
Anthony of the Desert)

Medinet Madi

T h e b a i d

← *Cyrenaica (in Libya)*

Gulf of Suez

Deir Mar Bulus
(Monastery of Saint
Paul of the Desert)

Monastery of
Saint Catherine
(Greek Orthodox,
not Coptic)

Gulf of Aqaba

Behnase
(Oxyrhynchus)

Nile River

Antinoopolis (Antinoe)

Deir Abu Fana

Deir Abu Hennis

Ashmunein (Hermopolis)

Monastery of
Apa Apollo

Gebel el-Tair (Monastery of the Mount of Birds)

Bawit

Deir el-Muharraq
(Burnt Monastery)

Deir el-Gabrawi

Asyut (Lycopolis)

RED SEA

Deir Dronqa
(Monastery of the Virgin)

Deir el-Ahmar (Red Monastery)

Deir el-Abiad (White Monastery)

Akhmim (Panopolis)

Sohag

Dakhla Oasis

Fau

Tabennisi

Dendera

Nag Hammadi

Qus

Kharga Oasis

Deir el-Medineh
(Monastery of the Town)

Medinet Habu

Karnak

Kharga
(and necropolis
of Bagawat)

Armant

Luxor (Thebes)

Deir el-Bahari (Northern Monastery)

Esna

Edfu (Apollinopolis)

COPTIC EGYPT

■ Monastery

○ City

0 ____ 300 km

0 ____ 175 miles

Nile River

Deir Amba Samaan
(Monastery of Saint Simeon)

Aswan

First Cataract

Philae

Further Reading

GENERAL

Atiya, A. S., ed., *The Coptic Encyclopedia*, 8 vols., 1991.

Coptologia (journal), 15 vols., 1981–95.

Coptology: Past, Present, and Future; Studies in Honour of Rodolphe Kasser, 1994.

COPTIC LANGUAGE, WRITING, AND LITERATURE

Crum, W. E., *Coptic Dictionary*, 1939, rev. 1961.

Lambdin, T. O., *Introduction to Sahidic Coptic*, 1982.

Mattar, N., *A Study in Bohairic Coptic*, 1990.

Smith, R., *A Concise Coptic-English Lexicon*, 1999.

Wallis Budge, E. A. Thompson, *An Egyptian Hieroglyphic Dictionary: With an Index of English Words, King List, and Geographical List with Indexes, List of Hieroglyphic Characters, Coptic and Semitic Alphabets*, 2 vols., 1978.

COPTIC ART

Baginski, A., and Tidhar, A., *Textiles from Egypt, 4th–13th Centuries CE*, 1980.

Carroll, D. L., *Looms and Textiles of the Copts: First Millennium Egyptian Textiles in the Carl Austin Rietz Collection of the California Academy of Sciences*, 1988.

Ebdel-Sayed, G. G., *The Coptic Museum and Old Churches, Cairo*, n.d.

Emmel, S., ed., *An International Dictionary of Institutions Holding Collections of Coptic Antiquities outside of Egypt*, 1990.

Friedman, F. D., ed., *Beyond the Pharaohs: Egypt and the Copts in the 2nd to 7th Centuries AD*, exh. cat., Rhode Island School of Design, Providence, 1988.

Rutschowscaya, M.-H., *Coptic Fabrics*, 1990.

HISTORY

Atiya, A. S., *A History of Eastern Christianity*, 1967, repr. 1968.

Barnes, T. D., *Athanasius and Constantius: Theology and Politics in the Constantinian Empire*, 1993.

Brakke, D., *Athanasius and Asceticism*, 1998.

Butcher, E. L., *Story of the Church of Egypt*, 1897, repr. 1997.

Campenhausen, H. von, *The Fathers of the Greek Church*, 1959, repr. 1963.

Cannuyer, C., "L'Ancrage juif de la première Eglise d'Alexandrie," in *Le Monde Copte* 23, 1993.

———, "Entre identités égyptienne, arabe et chrétienne: Les Coptes d'Egypte," in G. Audisio, *Réligion et Identité*, 1998.

Chadwick, H., *The Early Church*, 1974.

Cross, F. L., *The Early Christian Fathers*, 1960.

Davis, S. J., Lyster, W., and Hulsman, C., *The Holy Family in Egypt*, 2000.

Doorn-Harder, N. van, and Vogt, K., eds., *Between Desert and City: The Coptic Orthodox Church Today*, 1997.

Duchesne, L. (C. Jenkins, trans.), *Early History of the Christian Church, from Its Foundation to the Fourth Century*, 3 vols., 1950–51.

Dunn, M., *The Emergence of Monasticism: From the Desert Fathers to the Early Middle Ages*, 2000.

Evelyn-White, M. C., *Monasteries of Wadi'n Natrun*, 2 vols., 1926–33.

Gould, G., *The Desert Fathers on Monastic Community*, 1993.

Habib el-Masry, I., *The Story of the Copts*, 1978.

MacCoull, L. S. B., *Coptic Perspectives on Late Antiquity (Collected Studies)*, 1993.

Martin, A., *Athanase d'Alexandrie et l'Eglise d'Egypte au IVème siècle*, 1996.

McClellan, M. W., et al., *Monasticism in Egypt: Images and Words of the Desert Fathers*, 1999.

Meinardus, O. F. A., *Two Thousand Years of Coptic Christianity*, 1999.

Merton, T. (trans.), *The Wisdom of the Desert: Sayings from the Desert Fathers of the Fourth Century*, 1970.

Momigliano, A., *The Conflict between Paganism and Christianity in the Fourth Century*, 1963.

Neale, J. M., *A History of the Holy Eastern Church: Patriarchate of Alexandria*, 2 vols., 1897.

Oulton, J. E. L., and Chadwick, H., *Alexandrine Christianity*, 1956.

Patrick, T. H., *Traditional Egyptian Christianity: A History of the Coptic Orthodox Church*, 1996.

Pearson, B. A., *The Roots of Egyptian Christianity*, 1986.

Quasten, J., *Patrology*, 3 vols., ed. A. Di Berardino, 1950–60, repr. 1983; *Patrology: The Golden Age of Latin Patristic Literature from the Council of Nicea to the Council of Chalcedon*, 1986.

Regnault, L. (E. Poirier, trans.), *The Day-To-Day Life of the Desert Fathers in Fourth-Century Egypt*, 2000.

Roberts, C. H., *Manuscript, Society, and Belief in Early Christian Egypt*, 1979.

A Select Library of Nicene and Post-Nicene Fathers of the Christian Church, 1890, 1894.

Waddell, H. (trans.), et al., *The Desert Fathers:• Translations from the Latin (Vintage Spiritual Classics)*, 1998.

Wakin, E., *A Lonely Minority: The Modern Story of Egypt's Copts*, 2000.

Ward, B., and Russell, N., *Lives of the Desert Fathers: the Historia Monachorum in Aegypto*, Cistercian Studies No. 34, 1981.

Watson, J. H., *Among the Copts*, 2000.

Young, F. M., *From Nicaea to Chalcedon: A Guide to the Literature and Its Background*, 1983.

List of Illustrations

Key: *a*=above, *b*=below, *l*=left, *r*=right, *c*=center

Front cover: Head of a dancer, wool textile, 4th–5th century, Musée du Louvre, Paris
Spine: Detail of a mural painting, Monastery of Saint Paul, Egypt
Back cover: Representation of Saint Paul, Monastery of Saint Paul, Wadi Natrun, Egypt
1 Tapestry medallion, Musée du Louvre, Paris
2 Detail of a textile with a female face, wool and linen, 9th century, Musée du Louvre, Paris
3 Detail of a textile square with Aphrodite and Nilotic motifs, 6th century, Musée du Louvre Paris
4 Detail of a textile square with a bust of a figure, 7th century, Musée de Cluny, Paris
5 Detail of a textile square with a bust of a figure, 8th century, Musée du Louvre, Paris
6 Detail of a textile square with a bust of a figure with Nereids, wool and linen, 6th century, Musée du Louvre, Paris
7 Textile with male and female dancers, wool and linen, 6th century, Musée du Louvre, Paris

10 Lady with a *crux ansata*, shroud painted in encaustic on linen, c. 193–235, Antinoopolis, Musée du Louvre, Paris
11 Funerary stela of the female monk Rhodia, Staatliche Museen Preussicher Kulturbesitz, Ägyptisches Museum, Berlin
12 Shroud painting of a deceased man standing between Osiris and Anubis, c. 180, Staatliche Museen Preussicher Kulturbesitz, Ägyptisches Museum, Berlin
13a Ramses II making an offering to Amun-Ra, incised sandstone relief, c. 1290–1224 BC, Abu Simbel, Egypt
13b Statue of a priest of Onuris, stone, c. 300 BC, Musée du Louvre, Paris
14a Osiris, detail of a mural painting from the tomb of Horemheb, 18th dynasty, Valley of the Kings, Thebes
14b–15l The Flight into Egypt, icon, 18th century, Deir el-Suryani (Monastery of the Syrians), Wadi Natrun, Egypt
15r Detail of a tapestry medallion depicting stories from the life of Joseph, textile, Städtisches Museum, Trier, Germany

16l Saint Mark, painted wood icon, 6th–7th century, Bibliothèque Nationale de France, Paris
16r–17 Saint Mark arriving in Alexandria, detail of a mosaic, 13th century, Basilica of San Marco, Venice
18–19b The great Synagogue of Alexandria, mosaic, 5th century, Bet She'an, Israel
19al Cross decorating a *loculus*, necropolis of Alexandria, excavated by Jean-Yves Empereur in 1997
19ar Tombs at the necropolis of Alexandria, excavated by Jean-Yves Empereur in 1997
20a Drachma coined in the 13th year of the reign of the Emperor Trajan, bronze, c. 109–10, Bibliothèque Nationale de France, Paris
20b Oil lamp with an image of the port of Alexandria, clay, 1st century AD, National Maritime Museum, Haifa, Israel
21 Detail of Rylands Papyrus 457, John Rylands University Library, Manchester, England
22 Inner binding of Codex VII of the Nag Hammadi manuscripts, 4th century, Coptic

Museum, Cairo
23 Adam and Eve, detail of a fresco from the Fayum, 10th century, Coptic Museum, Cairo
24 *Plato Teaching Geometry* or *The Assembly of Philosophers*, Roman mosaic from Boscoreale, 1st century AD, Museo Archeologico Nazionale, Naples
25 The Sacrifice of Isaac, wool and linen textile, 5th century, Musée Historique des Tissus, Lyons
26–27l Statue of Saint Menas with camels, marble, 5th century
27 The Martyrdom of Saint Thecla, benediction ampulla, terracotta, Musée du Louvre, Paris
28 Christ and the Abbot Menas, panel painting, 6th–7th century, Musée du Louvre, Paris
29 Painting of a cross, late 6th century, Kellia, Egypt
30l Saint Athanasius, detail of a fresco from the Monastery of Saint Anthony of the Desert, Egypt
30r Coptic cross from Ethiopia, metalwork, 19th century
31 Miniature depicting the Ecumenical Council of 381, in Gregory of Nazianzus, *Homilies*, 880–83, Greek Ms. 510,

Index

Photograph Credits

AFP 108, 108b–9b. AKG Photothèque, Paris 12, 13a. All rights reserved 21, 22, 41, 63, 100. Archives Jean Clédat/Musée du Louvre, Paris 96a, 96b, 97. Archivio Scala 16r–17, 84. Artephot 78, 79, 81b. Artephot/A. Held 15r, 33, 59a. Asap 18–19b. Bibliothèque Nationale de France, Paris 16l, 20, 31, 48, 49a, 62, 76l, 76r–77, 81a, 83, 85b, 86–87, 90, 90–91b, 91a, 123, 127a. Nabil Boutros 92, 106, 108, 109. BPK 11, 54b. Bridgeman 98–99b. British Museum, London, 134. CEA/André Pelle 26–27. Editions Citadelles/Mazenod 35. Bruno de Clerfayt 30l. Dagli Orti 14a, 23, 24, 32, 36–37, 42b, 43, 44–45, 54a–55a, 60, 64l, 67, 74, 80, 89. Giraudon 46–47b, 75. IFAQ, Cairo 39. Andrea Jemolo 38, 50, 51a, 52, 68–69, 70, 72–73. Magnum/Eric Lessing 20, 21. Mission Suisse d'Archéologie Copte, Geneva 29, 34, 34–35. Le Monde Copte, Limoges 102a–3, 102b, 121, 127b. Coptic Museum, Cairo/photo Philippe Maillard 38–39, 52–53, 55b, 64r. Islamic Museum, Cairo 61. Metropolitan Museum of Art, 129. Musée Historique des Tissus, Lyons 25, 66. Musée du Louvre/C. Larrieu 51b. Musée du Louvre/photo Philippe Maillard 49b. Pushkin Museum, Moscow 40. Pierpont Morgan Library, New York 42a. Rapho/Sabine Weiss 101, 104, 105, 113. Réunion des Musées Nationaux front cover, 1–7, 10, 13b, 27, 28, 46–47a, 53, 56a, 56b, 57a, 57b, 58, 59c, 59b, 70b–71b, 71. Roger-Viollet 94, 95. Alberto Siliotti/Geodia spine, back cover, 14b–15l, 70, 93, 112. Sipa Press/Isabelle Simon 107, 100, 111. Henri Stierlin 30r. Sygma 19al. Victoria and Albert Museum, London 68.

Text Credits

The Coptic Encyclopedia, edited by Aziz S. Atiya, vol. 5, © 1991 by Macmillan Publishing Company, New York, by permission of the Gale Group. Cyril of Alexandria, *Homily Given at the Council of Ephesus,* in Adalbert Hamman, *How to Read the Church Fathers,* English translation © Copyright John Bowden and Margaret Lydamore, 1993, courtesy Les Editions du Cerf, Paris, and the Crossroad Publishing Company. From *Some Aspects of Coptic Painting* by Sirarpie Der Nersessian, in *Coptic Egypt,* Brooklyn Museum, 1944. Anatole France, *Thaïs,* 1890, translated by Basia Gulati, Copyright © 1976 University of Chicago Press. Edward William Lane, *An Account of the Manners and Customs of the Modern Egyptians, Written in Egypt during the Years 1833–1835,* 1836, © Copyright East-West Publications 1978, Den Haag and London.

Christian Cannuyer teaches ancient Near Eastern religions,
Christian church history, and Coptic language in the
Theology Department of the Université Catholique,
Lille, France. He has published many books and articles,
including a volume on the Copts (2d edition, 1996),
which won the 1991 Goblet d'Alviella Prize in the
History of Religions of the Académie Royale of Belgium,
and is editor of the Fils d'Abraham series, published in
collaboration with the Centre Informatique et Bible
of the Abbey of Maredsous.
President of the Société Belge d'Etudes Orientales
(Belgian Society of Eastern Studies) since 1994 and
member of the Administrative Council of the
Francophone Association of Coptic Studies, he also
edits the magazine *Solidarité-Orient* in Brussels.

To Ashraf and Bernadette Sadek

Translated from the French by Sophie Hawkes

For Harry N. Abrams, Inc.
Editor: Eve Sinaiko
Typographic designers: Elissa Ichiyasu, Tina Thompson, Dana Sloan
Cover designer: Dana Sloan
Text permissions: Barbara Lyons

Library of Congress Cataloging-in-Publication Data

Cannuyer, Christian, 1957–
 [Egypte copte. English]
 Coptic Egypt : the Christians of the Nile / Christian Cannuyer.
 p. cm. — (Discoveries)
 Includes bibliographical references and index.
 ISBN 0-8109-2979-1 (pbk.)
 1. Copts—History. 2. Egypt—History. I. Title. II. Series : Discoveries
(New York, N.Y.)
 DT72.C7 C3613 2001 00-049335
932—dc21

Printed and bound in Italy by Editoriale Lloyd, Trieste

There are more than 75 books in the DISCOVERIES® series.
For a complete list, please contact the Sales Department:

Harry N. Abrams, Inc.
100 Fifth Avenue
New York, N.Y. 10011
www.abramsbooks.com

ⲁⲃⲃⲁ ⲡⲁⲩⲗⲉ

Egypt, land of the Bible, has been home since the time of
Christ to an ancient sect of Christians called the Copts.
According to legend, Mark the Evangelist founded their
church in Alexandria in the 1st century AD, when Egypt was
under Roman rule and practiced polytheistic religions. Though
Egypt long ago became a Muslim nation, the Copts main-
tained their traditions and rites at monasteries and villages
throughout the Nile Valley, the river delta, and the
Mediterranean coast, and still do so today. Beautiful antique
textiles, mosaics, illuminated manuscripts, frescoes, bookbind-
ings, and monuments attest to their rich and venerable cultur
which drew inspiration from Egyptian, Hellenistic, and Nea
Eastern art. Modern Copts are the living descendants of the
ancient Egyptians, heirs to a splendid and unique patrimony.

51295

9 780810 929791

$12.95

ISBN 0-8109-29